# DRAW
## SPORTS FIGURES

by

Damon J. Reinagle

PEEL productions, inc.

Thanks to all my sports heroes for their inspiration;
Bill Mazeroski (2nd Baseman, 1960 Pittsburgh Pirates)
Larry Scott (first Mr. Olympia)
Howard Dulmadge (track coach, 1966 Berea High School)
Charles Reinagle (always my hero!)

Thank you all for teaching me the importance of setting goals!
—DJR

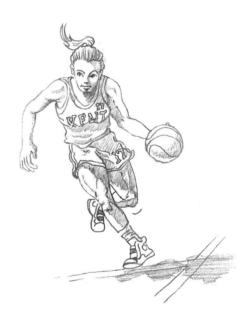

Manufactured in the United States of America

**Library of Congress Cataloging-in-Publication Data**

Reinagle, Damon J.
    Draw. Sports Figures / by Damon J. Reinagle
                p. cm.
    Summary: Provides step-by-step instructions for drawing sports
figures in action.
    ISBN 0-939217-32-5 (pbk.)
    1. Action in art--Juvenile literature. 2. Athletes in art--Juvenile
literature. 3. Drawing--Technique--Juvenile literature. [1. Athletes
in art. 2. Drawing--Technique.] I. Title.
NC785.R43 1997
743.4--dc21
                                                    97-25457

Distributed to the trade and art
markets in North America by

**NORTH LIGHT BOOKS,**
an imprint of F&W Publications, Inc.
4700 East Galbraith Road
Cincinnati, OH 45236

**(800) 289-0963**

# Contents

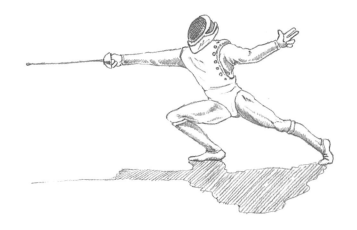

# Before you begin...

Break out that ball cap and glove. Place those shoulder pads and helmet clearly in view. Loosen up your dribbling, drawing fingers. Now, get ready to create some SUPER sports excitement with DRAW SPORTS FIGURES! We begin with simple instructions, some common sense drawing rules and basic shapes. As we advance we will add details, uniforms, symbols and shading to bring life to all our athletic figures!

It is important to begin at the beginning of this book and follow directions, one step at a time. If you do, you will be surprised at how easy it is to draw GREAT athletes in motion. If however you skip ahead without following the beginning instructions, you may end up a frustrated, unprepared artist. And that's sort of like being a hockey goalie without using protective padding or wearing a full-face hockey mask! So be prepared. Check out your drawing gear and ready yourself for some SUPER sports drawings.

## You will need:
- pencil
- pencil sharpener
- eraser
- paper
- ruler
- a place to draw
- SUPER POSITIVE ATTITUDE!

Let the games begin!

# Common Sense Drawing Rules

## Rule I - LOOK! See the shapes

If you look carefully you can see basic geometric shapes in everything. So before you begin drawing, LOOK at the final drawing of the athlete in motion. Observe the shapes—circles, ovals, squares, rectangles and triangles!

## Rule II - Sketch super lightly: always!

Light sketching helps create form and movement in figures. And erasing is much easier if you sketch lightly. So always sketch super lightly!

## Rule III - Be creative! Use your imagination.

You can become very good at drawing the step by step sports figures you see in this book. But the real satisfaction and excitement of being an artist is in creating original works—using your imagination. So be creative! Take the basic fundamentals of drawing figures from the pages of this book and apply them to your own drawings of athletes, based on illustrations or photos from sports magazines, cards and even the newspaper.

## Rule IV - Practice, practice, practice!

Drawing is like shooting baskets or riding a skateboard. To become really good you just have to do it, and then do it some more. Practice…you will get better!

# Sketch the shapes

As an artist, you need to know the structure of bones and how they move. But when you want to capture a fast moving figure, there's no time to draw the entire skeleton. Instead, learn to quickly sketch the shapes representing the structure of the body.

1. LOOK carefully at the detailed skeleton! Now, lightly sketch a circle for the head. Sketch two large overlapping circles for the chest. Sketch the shapes you see that form the lower body.

2. Observe the angle of each arm and leg. Compare these to the clock face. Using ovals (joints) and lines (rods), sketch the arms and legs.

3. Add large, overlapping ovals to shape the bulging arms. Outline and shape the muscular legs.

GOOD JOB! You have sketched an athlete in motion.

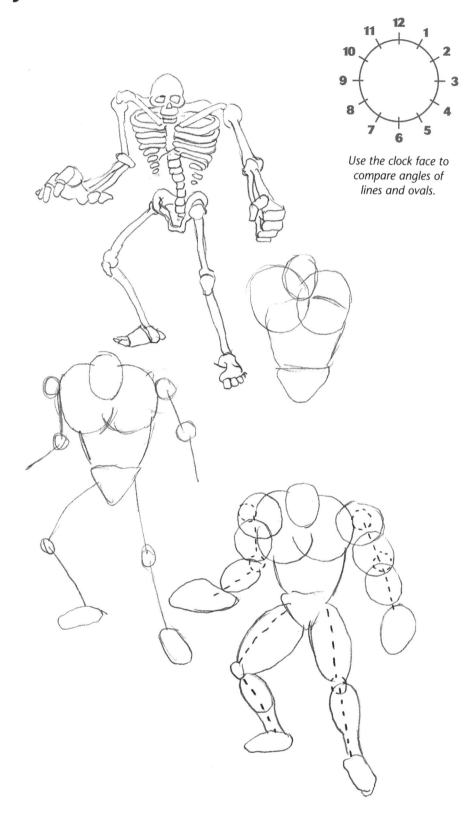

*Use the clock face to compare angles of lines and ovals.*

# CHAPTER 1
# BASEBALL

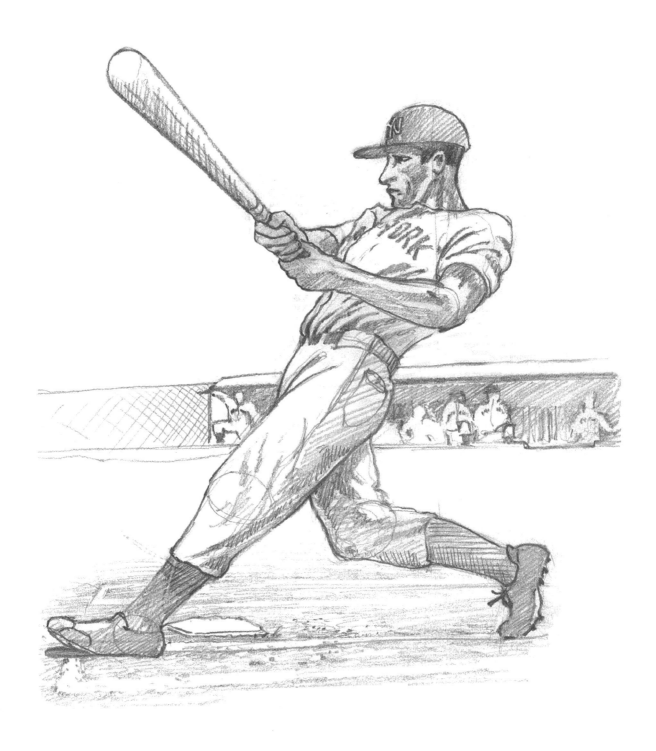

# Joltin' Joe

Joe Dimaggio, the great Yankee slugger of the 1940's was also known as the "Yankee Clipper." His batting pose and swing was quite distinctive.

1. LOOK at the final drawing. To capture this classic pose, begin with three oval shapes. Draw a tilted oval for the head. Add a peanut shaped oval for the upper body. Draw a round circle for Joe's hip.

2. LOOK carefully at the angle of Joe's arm and leg. Using rods (lines) and joints (ovals) lightly sketch the arm and leg.

3. LOOK at his other leg. Sketch the rods (lines) and joints (ovals) for this leg.

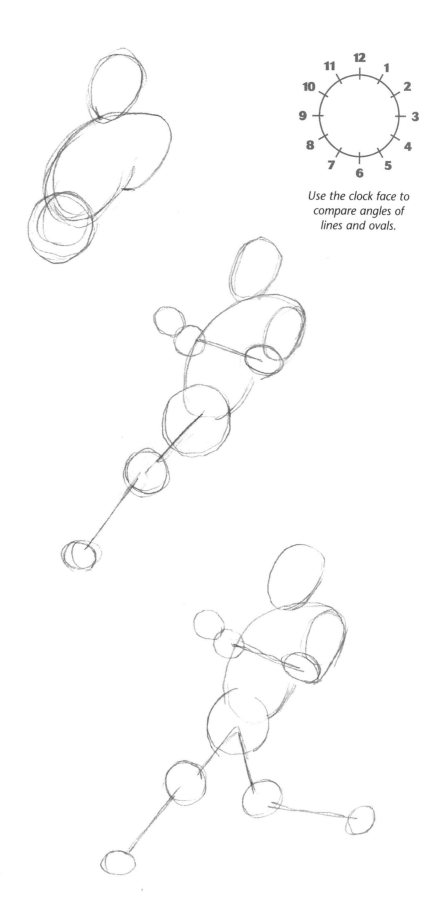

*Use the clock face to compare angles of lines and ovals.*

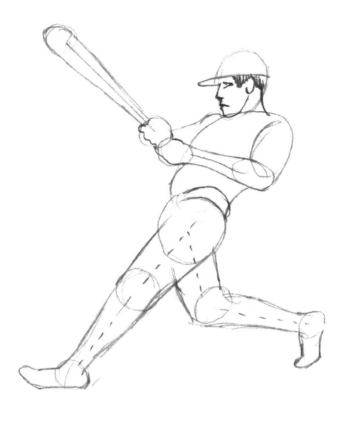

4. Add the cap visor. Draw the ear, eye, nose and determined mouth. Add the hair. Draw a curved line for the neck and another curved line to shape Joe's jaw. Draw a line for his right shoulder and arm. Draw squiggly lines to shape the knuckles of his hands.

Outline and shape his left arm and legs. Draw the feet. Erase rod and joint guidelines you no longer need.

LOOK at the angle of the bat. Draw the bat. Add two lines around his waist for his belt.

5. LOOK at the details in the final drawing. What other details need to be added? See the shading on the cap? On the bat? See any wrinkles? Add details and shading you see.

Don't forget the back pocket, socks, shoe laces, the cleats, and the....

## Sports Fact...

*Joe Dimaggio collected 91 hits over a two month period in 1941. He made history by hitting in 56 consecutive games.*

## Sports Question...

*What team finally stopped his hitting spree?*

# Slow Pitch Softball

There's nothing slow pitch about underhand softball pitchers. This powerhouse pitcher is about to deliver an underhand toss at about the speed of 80 miles per hour, or faster!

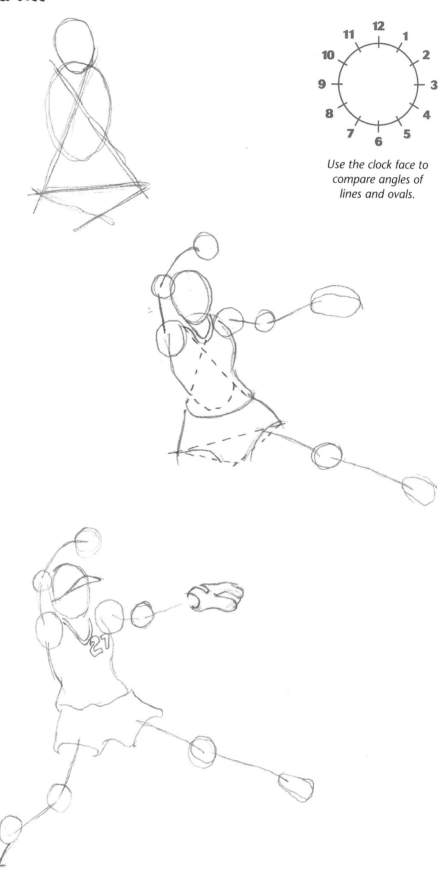

*Use the clock face to compare angles of lines and ovals.*

1. First, LOOK at the final drawing. What shapes do you see? Now LOOK at the first drawing. See the ovals and triangles forming the head and body of this athlete? Starting with the head oval, draw these connecting shapes.

2. Carefully look at the second drawing. Now, sketch the arms and hands using rods (lines) and joints (ovals). Notice her left arm has a large hand oval. This will become her glove. Sketch her extended left leg, using rods and joints. See how her body is formed around the triangles you drew in Step 1. Draw curved lines to shape her jersey top and shorts.

3. Erase any guide lines, you no longer need. Add curved lines for her cap visor. Draw a number on her uniform.

   LOOK at the angles on her back leg. Sketch her right leg and foot using rods and joints. Draw curved lines to shape her glove.

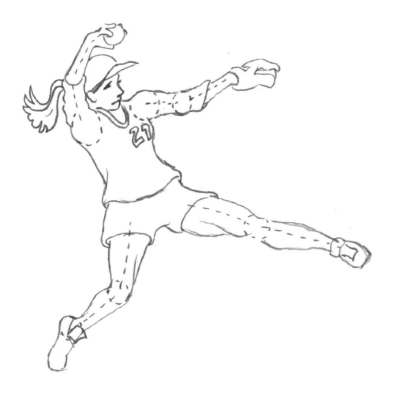

4. Now, let's shape the pitcher's arms and legs. First carefully observe the pitcher's right arm. See the way her pitching arm covers part of her cap and head? See the way her fingers are holding the ball? See the thumb under the ball, and the fingertips on the opposite side of the ball? Outline and shape her arm (and jersey sleeve) and fingers. Draw the ball. Add lines for her pony tail.

Next, outline and shape her left arm and sleeve. Add facial features. Add lines to shape her uniform.

Now, look carefully at her legs and feet. Outline her legs. Draw her shoes.

5. Now, for the details that will bring our pitcher to life....

Observe the light and dark areas. See the shading and shadows? Add all the details you see.

PERFECT PITCH!

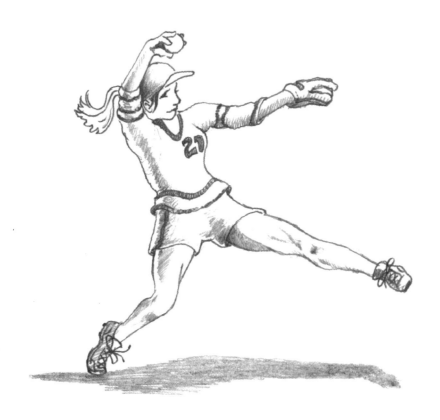

# The Catcher

The catcher crouches behind the batter and catches the balls thrown by the pitcher.

1. To capture this catcher in action, sketch an oval for the head. Sketch a bigger oval for the body, with a flattened top for his shoulders.

2. Lightly sketch the four cross lines to begin the catcher's mask. Sketch a line from the body oval to form his left arm. Sketch a large oval at the tip to start the catcher's mitt.

   Below the body oval, draw a rectangle for the cup pad. Draw three curved lines to shape his left thigh. Sketch one large oval to shape the knee and two small ovals to form the shoe.

3. Add additional lines to the catcher's mask. Using rods (lines) and joints (ovals), sketch the throwing hand, with ball, and the extended right leg.

   Draw the lines forming the neck and seam of the chest protector. Outline and shape the mitt arm. Draw a small circle in the center of the mitt. Outline and detail the shin guard.

   Erase guide lines.

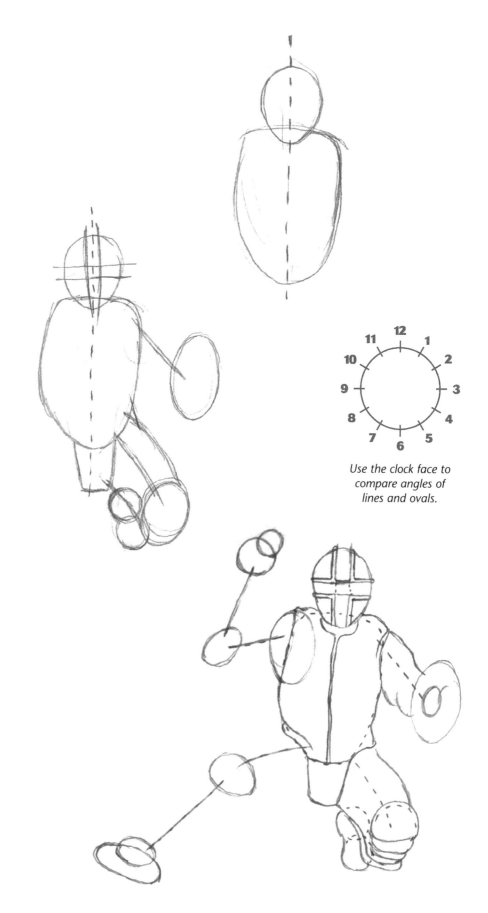

Use the clock face to compare angles of lines and ovals.

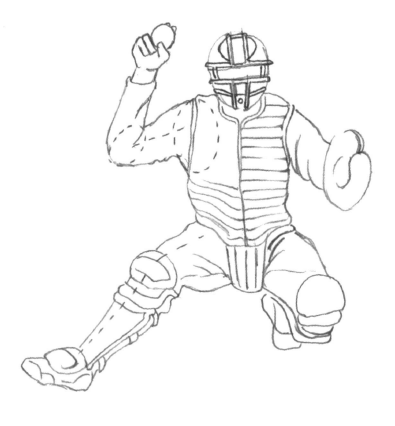

4. Outline and detail the mask. Outline and shape the catcher's right arm, hand and fingers. Outline and shape his extended leg, shoe, and the shin guard.

Erase guide lines you no longer need.

Add lines to shape the chest guard. Draw additional lines, across the front of the chest guard, to suggest pleats. Add pleat lines on the cup.

5. LOOK at all those details! See the shading and shadows.

Starting at the top, add additional lines to detail the mask. Draw lines to suggest the facial features on the face behind the mask. Detail and shade the chest protector. Add pin stripes to the uniform legs and sleeves. Draw the stitching on the baseball.

LOOK again. Add any additional details you see. Don't forget to draw home plate. Add the catcher's cast shadow....

Ready to "PLAY BALL!"

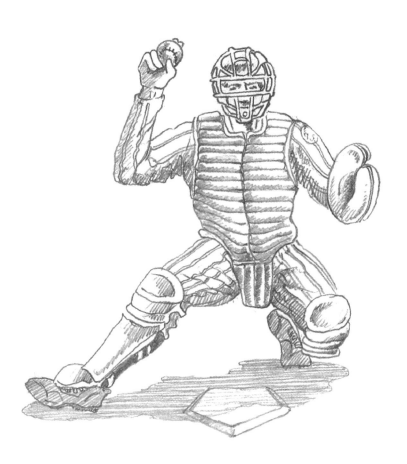

# Snaggin' that Line Drive

When one team is at bat, the other is in the field. Any infielder will tell you that one of the most challenging hits to field is the line drive—where the bat hits the ball in the center, and it travels straight and fast.

1. LOOK carefully at the final drawing. This infielder is flying sideways across the field to catch a "fast one."

   First sketch the mitt oval. Then sketch the outstretched arm—2 lines, 2 ovals. Next, sketch the head circle, above the shoulder oval. Draw the long, flattened body oval. Add a large circle for the hips, a line for the thigh, a circle for the knee, another line for the lower leg. Sketch a rectangle for his feet.

2. Draw the visor. Outline the player's profile. Outline and shape his right arm. LOOK at the angle of his left arm. See how the arm and hand are positioned, below the body, to cushion his fall? Sketch ovals and a line for this arm. Outline the jersey top and belt. Outline and shape the leg. Draw lines to form the feet from the rectangle shape.

3. Outline and shape his left arm and hand. Draw the mitt. Now, STOP! LOOK! Try to find all the small details. Add the details and shading you see.

GREAT CATCH! GREAT DRAWING!

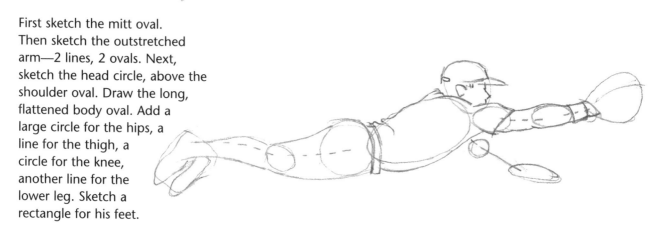

# Draw a baseball glove

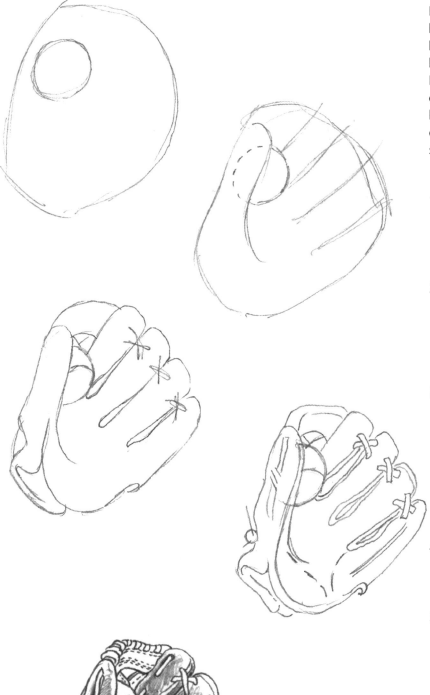

Ever take a really close look at a baseball mitt? At first glance it looks like a maze of leather, laces, stitches and autographs. BUT, in reality it is a collection of basic shapes and curving lines. LOOK at the finished drawing on this page. See the shapes and lines?

1. Lightly sketch a circle for the baseball you're certain to catch. Sketch a large oval for the glove itself.

2. Draw a curved line for the thumb. Erase the part of the baseball hidden by the thumb. Draw four angled lines for the fingers.

3. Outline the fingers. Draw three "X" shapes to begin the laces connecting the finger tips. Draw the web between the thumb and index finger. Draw curving lines at the bottom of the mitt to shape the opening.

4. LOOK! then add additional lines and other details you see.

5. To create texture and shading, more details are needed. Add more laces, more knots, more stitching, and lots of shading.

   LOOK carefully at the glove. Add all details you see.

   Don't forget the stitching on the ball. How about the autograph?

# Remember the athlete in motion...

on page 6, whom we stripped, of skin and muscle, right down to his skeleton? He's back, and up to bat!

Let's continue the drawing and see if we can bring this athlete to life with some muscle, skin, a summer uniform, and a BIG bat for those huge hands.

4. LOOK carefully at the final drawing. Starting at the top of his head, draw scratchy lines for his spiked hair. Sketch the eyes, nose, mouth, and his right ear. Sketch a line on each side for his collar bones. Outline and shape his arms, hands, and fingers. Add his skimpy body suit. Outline and shape his legs and feet.

5. Observe the light and dark areas. Add more hair spikes. Detail and shape his face. Add curved lines to accent his upper arms and biceps. Go over the outline and shape of his arms, body and legs. Add the muscle lines to his legs. Draw his shoes with shading and laces.

   What other details do you see? Cast shadow? Bat? Draw these.

   Wow! Awesome athlete!

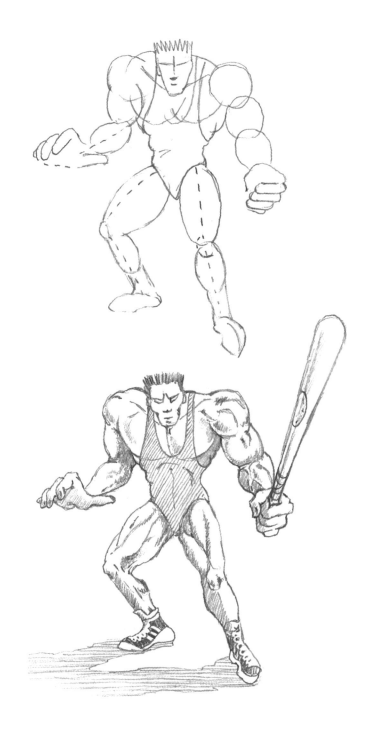

# FOOTBALL

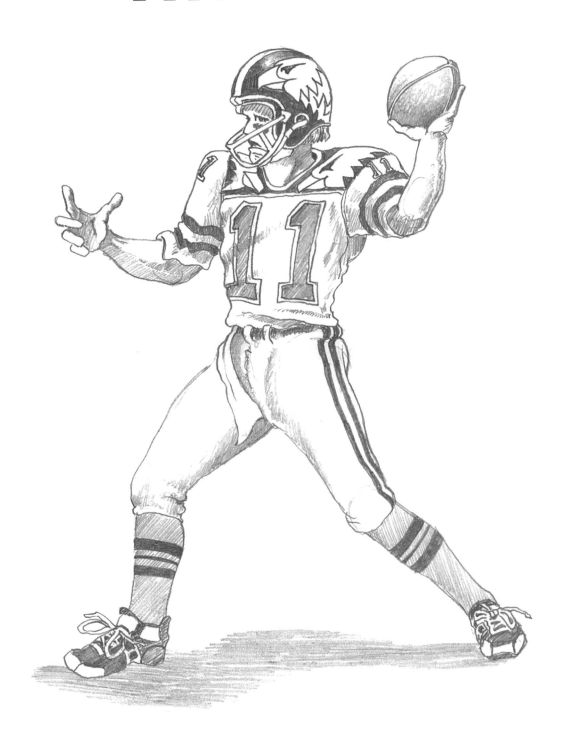

# The Quarterback

While his offensive linemen hold off oncoming rushers, our star quarterback stands his ground, behind the scrimmage line ("in the pocket"). He's poised and ready to throw a la Joe Montana!

1. LOOK carefully at the final drawing. Sketch the head oval. Draw a curved shoulder line. Sketch the body oval. Sketch the overlapping fan shape for the pelvic area.

2. Using rods (lines) and joints (ovals) sketch the quarterback's shoulders and arms. Add the large oval above his left arm for the football. Now sketch lines and ovals to form his legs.

3. Starting at the top, outline the helmet and his head. Outline the arms and shape the football. Outline the upper body. Outline the legs. Draw the shoes.

   Erase guide lines. Clean up smudges with your eraser.

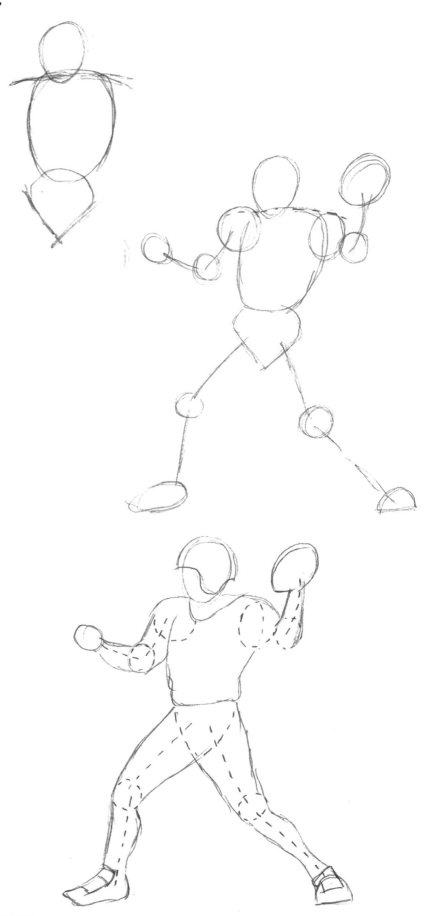

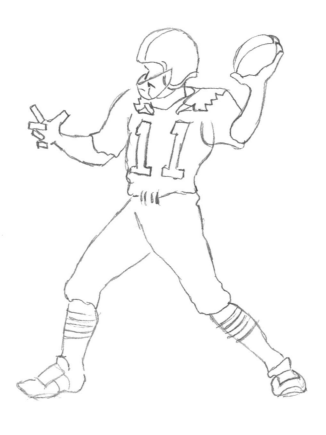

4. Add lines to shape the helmet. Add his mouth, nose and chin. Add lines for the face guard.

   Look at his uniform. Add the eagle head design on his padded shoulders, or draw your favorite team logo. Draw a numeral for his jersey. Draw four short lines for belt loops. Outline his uniform pants and socks. Add more shoe lines.

   Now look at our quarterback's free hand. See how his thumb and index finger stick up to form a kind of "U" shape. See the rectangle shaped fingers? Draw his right arm and hand. Now, check out the position of his left arm and hand. See how his thumb and index finger rest under the football? Draw his left arm and hand.

5. What logo did you draw on his shoulders? Add this logo to his helmet. Draw lines to shape the face guard bars, add a chin strap. Add his eye. Detail his uniform with stripes on his sleeves, small numerals on his shoulders, double lines on his chest numerals, dark stripes on his socks, laces on his shoes....

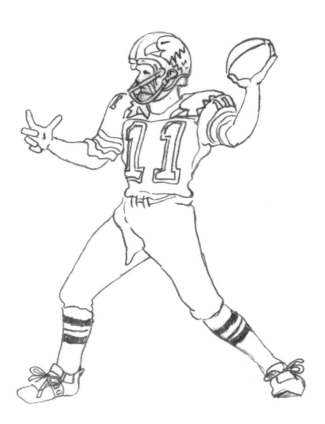

6. Look at the drawing on page 17. See the light and dark areas? Add shadows and shading, and any other details you see. Don't forget the towel hanging from his belt.

   This star QB is ready to throw a pass and score some points.

# The Receiver- Side Line Completion

One of the most athletic feats a receiver can accomplish is to catch a sideline pass while keeping both feet in bounds. Here our receiver is doing just that!

1. LOOK carefully at the body angles in the final drawing. See the long arc drawn above the body ovals? This guide line will help you draw the body ovals and lines at their correct angle.

   First, sketch the head oval. Next, sketch the longer body oval. Sketch the hip oval, then the thigh oval. See how these overlap. Sketch a circle for the knee, an oval for the calf. Add a line for the leg bone. Sketch an oval for the foot.

   Is your receiver stretched out, in the correct position to receive the ball? If not, try again until you get the angles just right.

2. Add three contour lines to the head oval to form his helmet. Look, then sketch his arms using rods and joints. Draw his fist shaped hands. Outline his upper body, legs, and foot.

   Erase any guide lines you no longer need. (They're easy to erase. Right? Because you ALWAYS sketch lightly—right?)

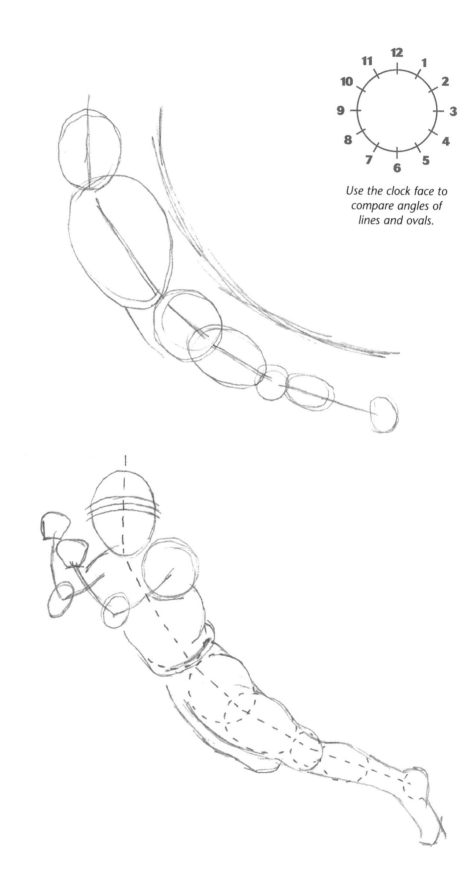

Use the clock face to compare angles of lines and ovals.

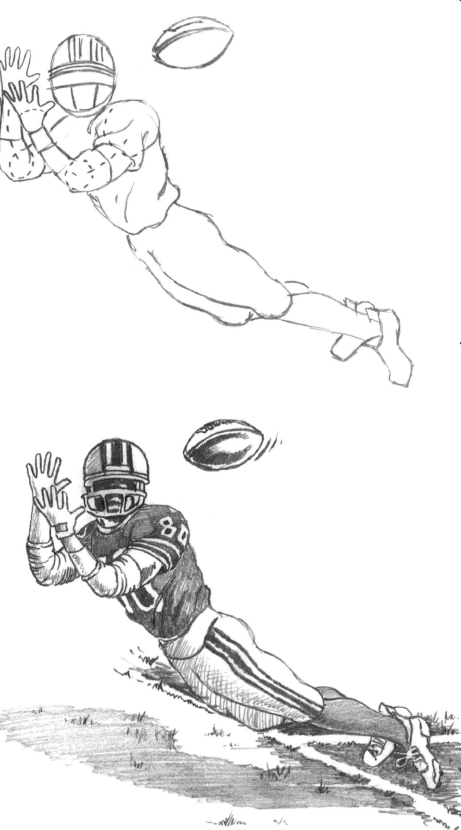

3. Add more lines—vertical and horizontal—to shape the helmet and the face guard. Outline the arms. Draw the sleeve lines of the jersey top and add lines to form the elbow guards and wrist bands. Draw the fingers on each hand. Draw a curved line, above his left knee, to shape the calf of his right leg. Add the heel and front of his right shoe.

Erase guide lines you no longer need.

Don't forget to draw the football!

4. LOOK at the final drawing! Observe the light and dark areas. See the shadows, the shading. What other details do you see?

Shade the football and add lines to show it's flying fast. Add details and shading to the helmet and face guard. Darken and detail the face. Shade and detail the uniform. Add lines to shape the gloves and the elbow pads.

Detail the shoes with cleats on the bottom, and add laces on top.

Draw the field with the boundary lines and stubby grass lines.

GOOD JOB!

# Up The Middle

The fullback stands behind the quarterback. When the other team is lined up to stop him, he must be strong enough to push through their scrimmage line.

1. Study the final drawing of this fullback. Notice the tilt of his helmet and body. He is bent forward, his hands and arms protecting the ball.

   Sketch a circle for his helmet and a large egg shaped oval for his upper body. Sketch a half circle for his large right shoulder. Using rods (lines) and joints (ovals) sketch his hip and legs. Add two "D" shapes with an extended line to begin his shoes.

2. Starting at the top, sketch a rectangle under the helmet oval, to begin the face guard. Using rods (lines) and joints (ovals) sketch his right arm, connecting to his big shoulder. Draw a football shape just above his wrist. Again using rods and joints, sketch his left arm touching the football. Outline and shape the hip, legs and shoes.

*Use the clock face to compare angles of lines and ovals.*

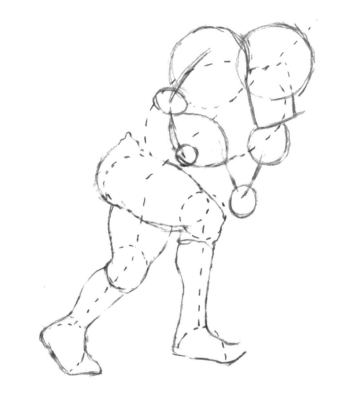

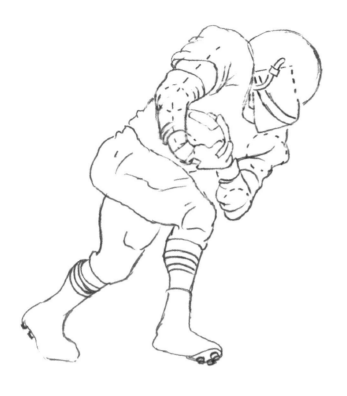

3. Now that we have the basic shape, we can add details. Starting with the face guard, draw two curving diagonal lines across the rectangle, below the helmet. Add the chin strap. Outline the padded shoulders and jersey sleeves. Outline the arms. On each forearm sketch an elastic elbow guard. Draw the gloved hands around the football.

Sharpen the outlines on his legs. Add stripes on each calf to begin his socks. Outline his shoes, add cleats.

Erase guide lines.

4. LOOK at the light and dark areas. See the stripes, the numerals, the shading, the cross bars? Detail the helmet and face guard. Shade in the fullback's face under the helmet.

Now look carefully at the uniform. Add the stripes and numerals you see. Detail and shade the football. Shade his socks. Sharpen outlines and detail his shoes. Add the ankle tape.

LOOK again! See any more details? Add these.

FABULOUS FULLBACK!

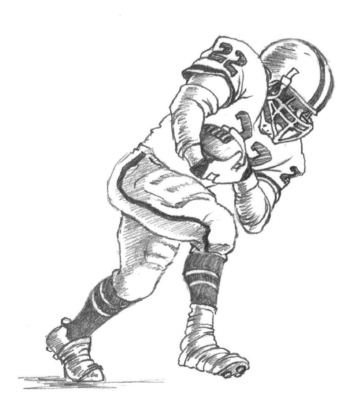

Draw SPORTS FIGURES    23

# The Helmet and Football

The helmet and the football are both used in an action packed game, and they are both based on geometric shapes. The helmet is a circle shape and the football is a oval shape.

## THE HELMET

1. Sketch a circle and a half oval shape overlapping it, for the face guard.

2. Sketch another half oval shape inside the first to form the face guard bars. Sketch a horizontal line, from the front of the helmet. Draw a curved line to form a "U" and a small circle for the ear hole. Draw a small curved line at the back of the helmet to shape the base.

3. Outline the helmet. Add a cross bar to the face guard. Outline the face and base rim of the helmet. Draw a circle inside the ear circle.

4. Add the chin strap. Design a team logo of your choice and add it to your helmet. (I drew flames! HOT, AY?)

## THE FOOTBALL

1. Sketch a long oval.

2. Divide the oval into three sections, making the center one larger than the end ones. Add lines for the stripes and the stitches.

3. Sharpen the outline. Add details and shading. Touchdown!

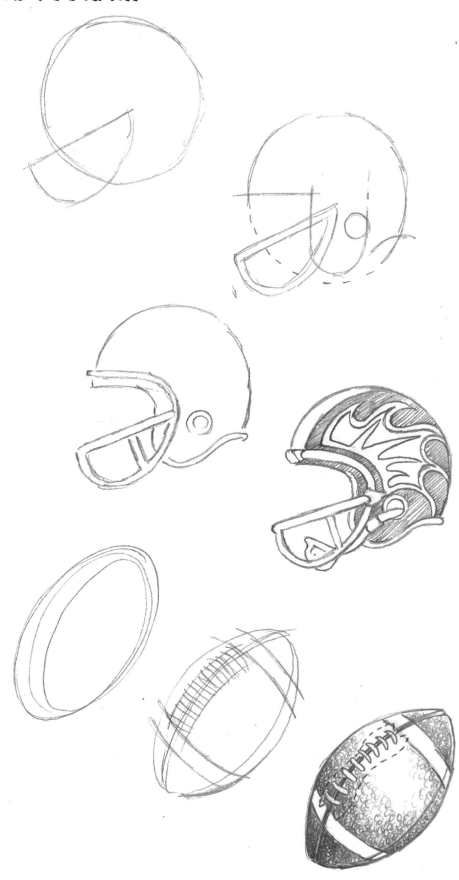

# BASKETBALL

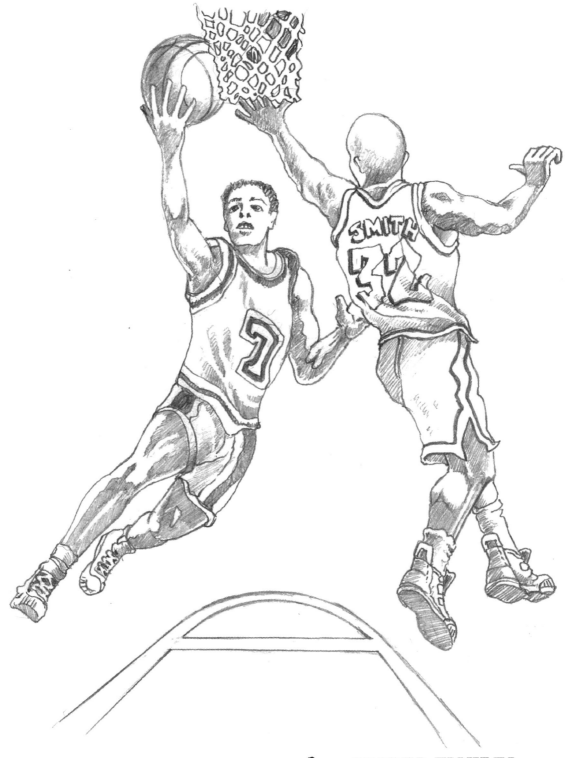

# Fingertip Roll

This basketball star is gently rolling the ball off the ends of his fingertips, as he streaks up the court toward the basket to score more points.

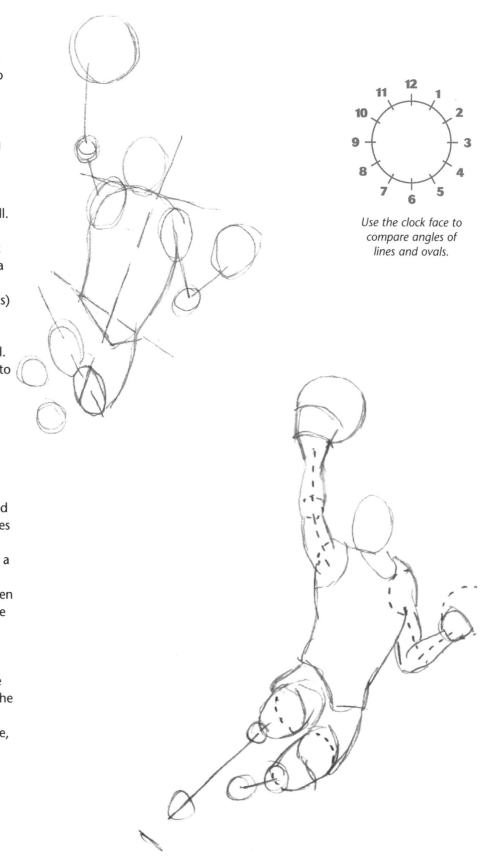

1. To capture this fast moving player in action, stop and look at the final drawing. Check out the angle of his body, his head, and the ball.

   Sketch the head oval. Next sketch the body oval with a triangle shape base. Using rods (lines) and joints (ovals) sketch the arms. Sketch a large circle at the tip of his right arm for the basketball. Draw a line from his waist to begin his left hip. Sketch two ovals to form the leg openings on his shorts. Below these, sketch knee joints.

2. Outline the upper body and arms. Draw two curved lines under the ball to begin his outstretched fingers. Draw a small oval inside his left hand oval, to shape his open palm. Add lines to form the collar and sleeve openings on his jersey. Sketch the thigh ovals (connecting to the knee ovals). Sketch the rods and joints that form the legs. Sketch a slanted line beneath his extended ankle, to begin the base of his right foot.

*Use the clock face to compare angles of lines and ovals.*

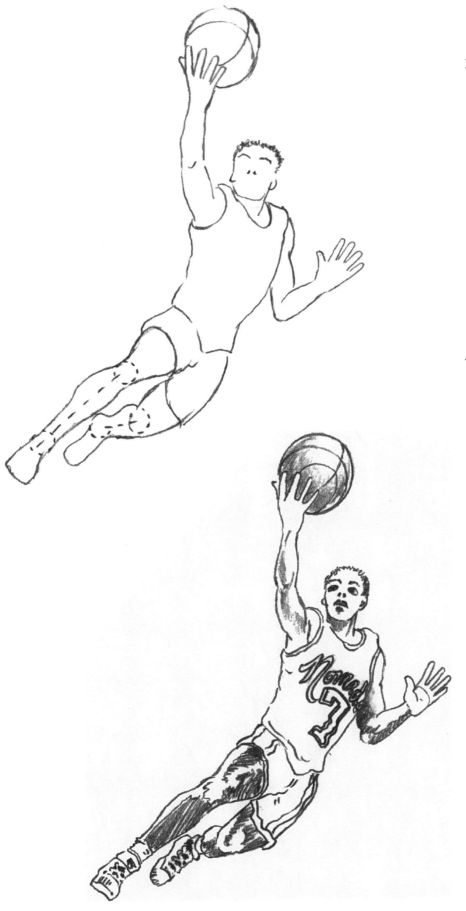

3. Outline and shape the head. Add ears, nostrils, curved eyebrows, and squiggly lines for hair. Outline and shape the upper body and arms. Draw the fingers and thumb on his right hand. Sketch two curved lines around the ball to accent its roundness. Draw the fingers and thumb on his left hand. Sharpen uniform lines. Outline his legs and feet.

Erase guide lines and clean up smudges.

4. What's missing? Facial features, shading, shadows, numeral, logo.... Make up a team name. Place it on your jersey. Add a numeral, add piping around the collar and sleeves. Add shading and shadows. Design some "designer" shoes for your player.

What about the basket, and the court? Turn back to page 25. Take your time. Observe the finger tip lay up of this graceful, airborne player.

Add more details to your drawing.

**Draw SPORTS FIGURES** 27

# Breakin' to the Bucket

This player is unstoppable as she breaks towards the basket, dribbling the ball all the way.

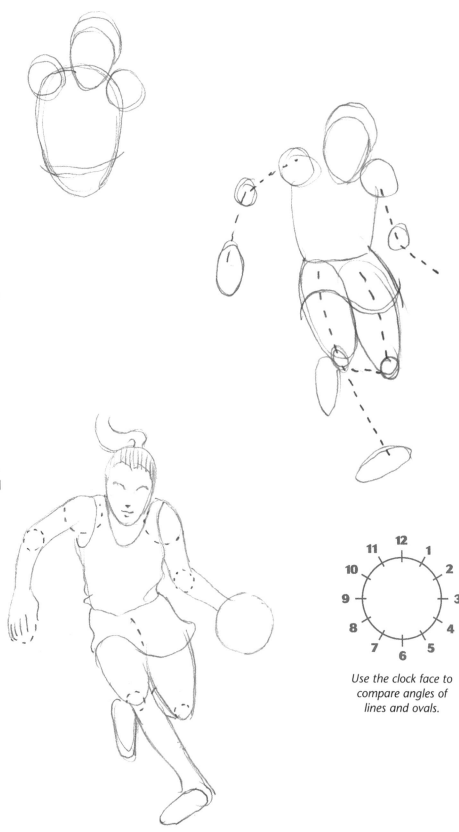

1. LOOK at the final drawing. What shapes do you see?

   Lightly sketch the head oval and the half circle on top for her hair. Next sketch the large egg shaped body oval. Sketch a line at the bottom for her waist. Sketch two shoulder circles.

2. From the shoulders, sketch the rods and joints to shape her arms. Draw a good sized oval for her right hand. Sketch long ovals for her thighs. Draw a curved reverse "S" across her thighs to shape the bottom of her shorts. Sketch the ovals and lines to shape her knees, lower legs, and shoes.

3. Let's liven up this hoopstress with hair lines and a ponytail hair-do. Add eyebrows, a nose and a mouth. Outline her right arm and hand. Outline and shape her left hand and the basketball. Draw lines to shape her upper body and wrinkled jersey.

   Outline her shorts and thighs. Outline her calves and feet.

   Erase guide lines.

*Use the clock face to compare angles of lines and ovals.*

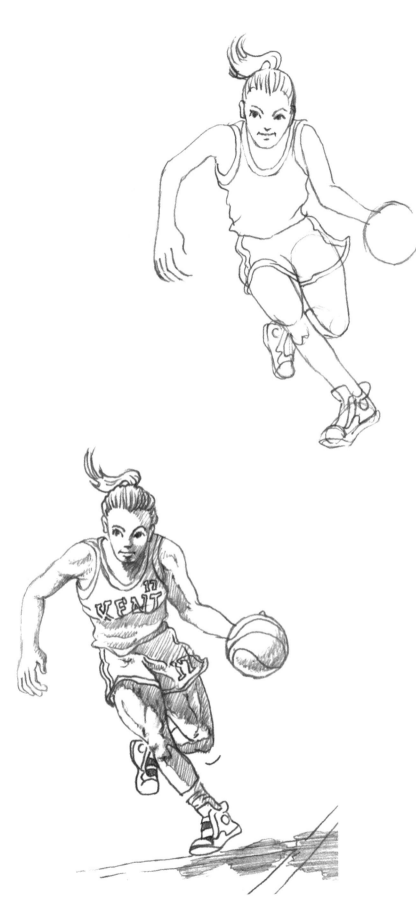

4. Add more hair lines. Draw her facial features. Draw the piping around the neck and sleeves of her jersey top. Sharpen the outline of her right arm and hand. Add the piping to her shorts.

   Look at the many lines forming her shoes. Draw these.

5. Carefully observe this final drawing. See the light and dark areas. Light coming from above and the left creates shading on her right side. Add the shading and any shadows you see.

   Draw the numerals and a team name on her uniform. I chose Kent, my alma mater. Add lines to accent her muscles, detail her shoes and socks.

   Don't forget the lines to show the spherical shape of the ball. What about the court lines and the cast shadow?

   Clean up with your eraser.

   GO on! Lookin' GOOD!

## Sports Fact...

*Ollamalitzli was a 16th century Aztec basketball game played in Mexico.*

## Sports Question...

*Who invented modern basketball? What Year?*

# Hang Time

From the time your feet leave the hardwood floor until the moment you slam home the jam, you are in for some serious hang time.

1. LOOK at the final drawing. See how this player is floating in hang time?

   Sketch the head oval. Next sketch the shoulder ovals. Using lines and ovals sketch the arms over the head. Sketch a large oval for the ball, and a smaller oval for his left hand.

2. Add lines to shape the eyebrows, nose and mouth. Outline the arms and hands. Outline and shape his jersey top. Draw an oval to begin the hoop.

   Erase guide lines you no longer need.

3. Sharpen the outline of his arms and jersey top. Add two long rectangle shapes to begin his shorts. Sketch two knee ovals, and two lines for his calves. Draw half circles with an extended line to begin the shoes.

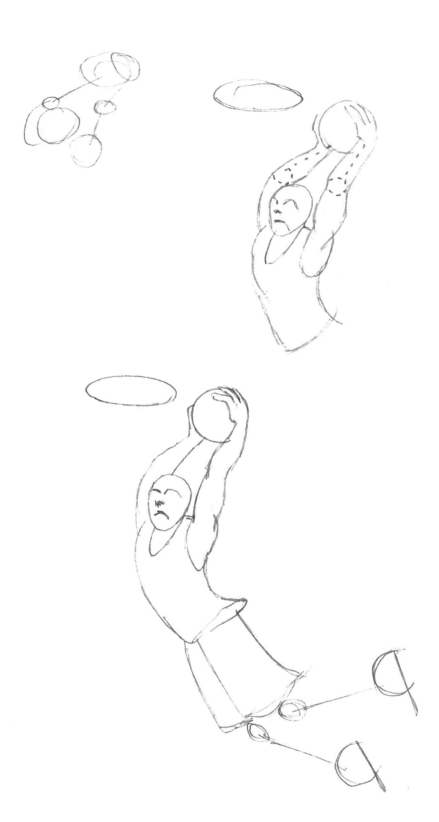

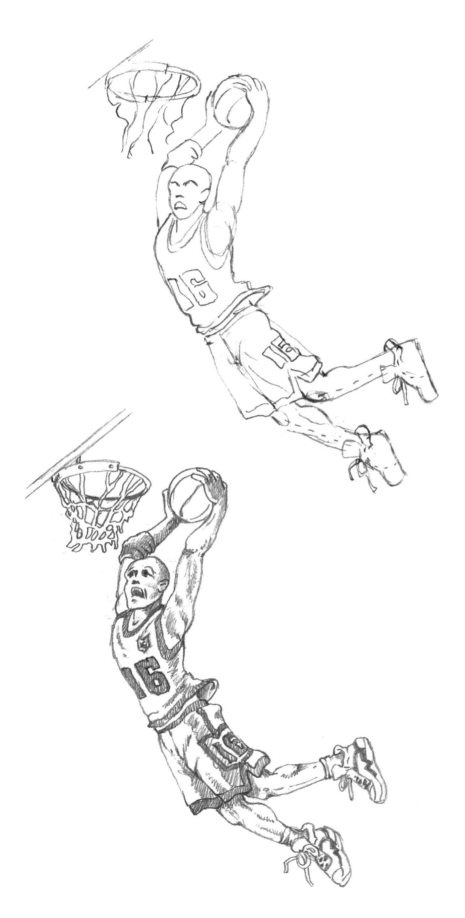

4. LOOK again at the final drawing.

   Starting at the top, outline the hoop. Add wavy lines to begin the net. Draw a slanted line for the backboard.

   Draw curved lines on the ball. Draw the elbow pad on his right arm. Add his ear and lower lip. Add lines to sharpen and shape his uniform. Draw lines for the piping and the numerals. Outline his legs. Add lines to shape his shoes.

5. Observe the light and dark areas of this final drawing. Check out the details.

   Add another line to the backboard. Add more lines to shape and shade the net and hoop. Go over the lines on the ball. Add shading to his arms, elbow pad, face, neck, throat. Add shading and detailing to his uniform.

   What's missing? Add it now.

# Design a Team Logo

Exciting teams demand exciting logos. Lots of professional teams have updated mascots and logos designed to stay stylish. Right now, San Diego doesn't have a professional basketball team. What if they got a new team? Could you design their logo? How does the San Diego Cobras sound?

1. Sketch three connecting ovals and a half oval on top for the cobra's head.

2. Add a ball with a curved line on it. Erase the guide lines.

3. Add eyes to the head. Draw two curved lines down from the head and then back under the ball, to begin the snake's body.

4. Add the nostril and a curved line inside the mouth. Draw several short lines across the stomach. Draw curving lines from the ball area to begin the winding tail.

5. Add the reptilian sections to the head, face and down the hood. Add lines to detail the stomach ripples. Draw dark thick lines around the basketball.

6. Add the fangs, and a tongue. Sharpen outlines and shade.

   Super stylish b-ball logo!

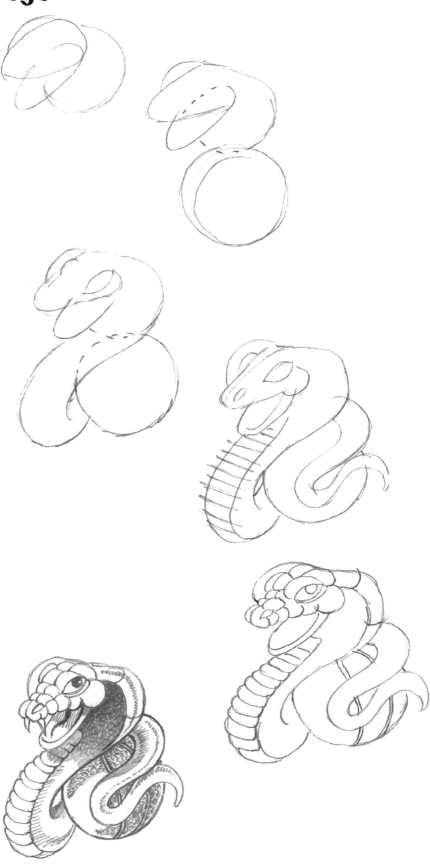

# OTHER TEAM SPORTS

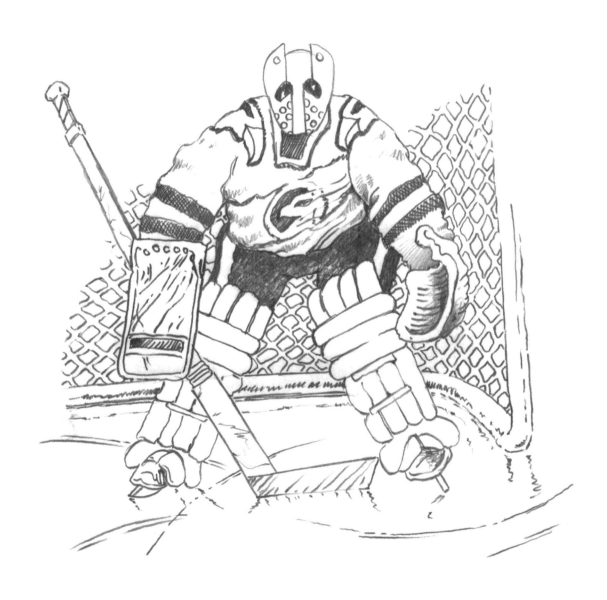

# Ice Hockey Goalie

In ice hockey, the goalkeeper's goal is to block the opposing team's puck with his glove or stick, to keep the opposing team from scoring a goal.

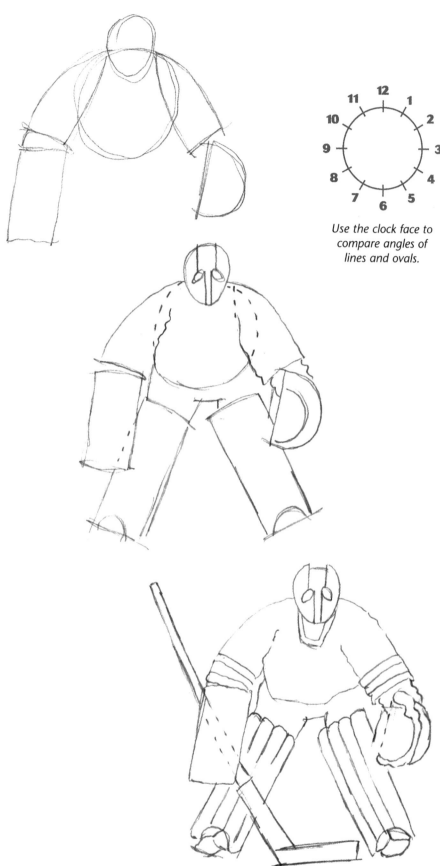

*Use the clock face to compare angles of lines and ovals.*

1. Check out our goalie friend in the final drawing. He's loaded with padding and equipment. Can you see the geometric shapes shaping him?

   Sketch the head oval. Sketch a large circle for the body. Sketch lines to form his "bullet shaped" arms. His stick glove is a rectangle and his glove is a letter D shape. Sketch these now.

2. Add the oval eyes, and the mask lines. Outline his upper arms and body to form his wrinkled jersey top. Sketch another "D" shape inside the first to form his glove.

   Look at his lower body and legs. See how they connect. Sketch these lines, and include a small half circle at the bottom of each leg.

   Erase guide lines.

3. Add stripes to his sleeves and a collar around his neck. Sharpen the waist line. Draw his stick.

   Add lines to shape the glove. Note how the long vertical rolls of padding divide his leg pads into four sections. Draw these. At the bottom center of the pads draw lines to begin the skates.

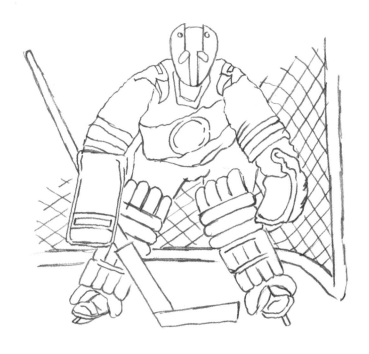

4. Sharpen all outlines. Draw two small circles on the mask. Lightly sketch eagle heads on each shoulder, or sketch whatever you wish for your logo. Draw a wide strip and circle logo across his jersey front. Detail gloves. Add diagonal pads across the vertical ones on the legs. Add lines to shape the skates.

Draw lines to shape the goal.

5. Your goal is to super detail this guy now! First carefully observe all details and shading in the final drawing. READY? GO for the goal!

Don't forget the skate lines in the ice.

GREAT GOALIE! He's ready to rumble!

## Sports Fact...

*Terry Sawchuk was called "Mr. Shutout" with a record of 103 shutouts in a 971 game career.*

## Sports Question...

*Who was known as "Mr. Goalie"?*

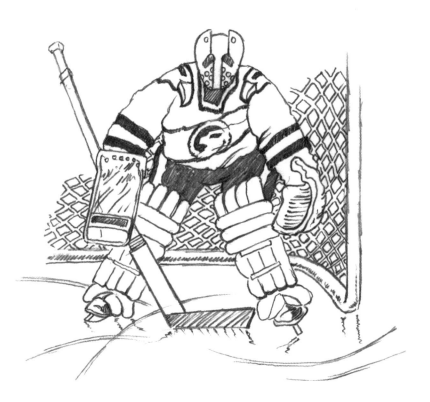

Draw **SPORTS FIGURES**      **35**

# Soccer Goalie

Soccer is an exciting ball game played by two teams, each of 11 players. The goalkeeper (one on each team) is the only player allowed to play the ball with his hands or arms, and he may only do so within his own penalty area.

1. LOOK at the final drawing of this goalie. Notice the unique perspective? He's leaping right off the page at us! His glove is actually larger than his head. His legs and feet appear smaller and further away. As you draw, compare angles in the drawing with the clock face.

   Lightly sketch the head and body ovals. Draw a "V" shaped collar. Sketch the rectangular thighs; the front one at the same tilt as the body. From the upper right side sketch the outside edges of the goalie's glove.

2. Starting at the top, draw jagged lines for wild hair. Add the ear, and nose and mouth profile. Add another collar line. Using rods (lines) and joints (ovals) sketch his right arm. Draw his large right glove. Sketch the soccer ball, with its pentagon design. Look at the shapes in the lower legs and feet. (The front leg shin shows, the rear shin doesn't. This foreshortening gives the illusion of proper relative size.) Sketch these shapes.

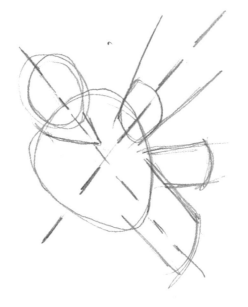

*Use the clock face to compare angles of lines and ovals.*

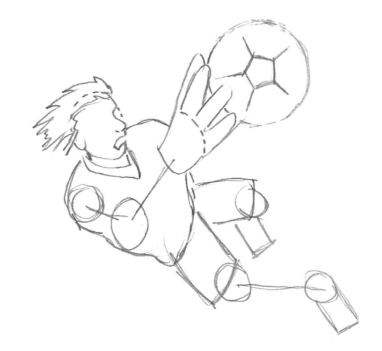

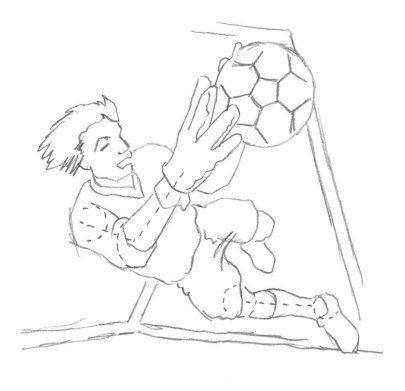

3. Sketch the goal lines, behind the goalie.

Sharpen the hair outline. Draw the eye and eyebrow. Outline his right sleeve and arm. Shape the glove. Draw more pentagon shapes on the ball. Draw a line under the ball for his left hand. Add lines above the ball for fingers. Outline and shape his wrinkled uniform. Outline his legs and shoes.

Erase guide lines. Clean up any smudges with your eraser.

4. Observe the contrast of light and dark areas, and shading in the final drawing.

Starting with the ball, shade in the six dark pentagons. Detail and shade his gloves. Shade his forearm. Add stripes to his jersey top. Darken his mouth and hair. Detail and shade his shorts, legs and shoes.

Looks like our goalie is ready to make that game saving catch! OOPS! We're missing the net. Using the net on page 35 for reference, draw the net.

Don't forget the scruffy tufts of grass.

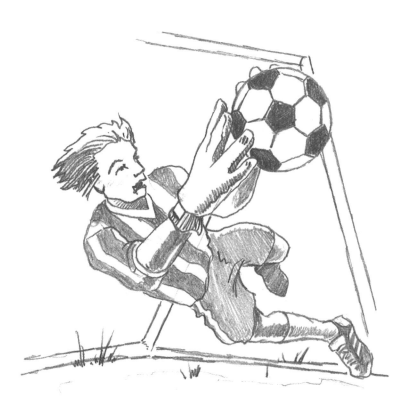

Draw **SPORTS FIGURES**    **37**

# Volleyball-the Dig

One of the most exciting and demanding team sports around is volleyball. Whether in a gym or on the beach, a match is always fast paced and thrilling for athletes and spectators alike!

1. LOOK at the position of this player in the final drawing. What shapes do you see?

   Sketch the head oval. Add a curved hair line. Using the rod and joint system, sketch the shoulders, arms and hands. Notice how they all join to create a triangular shape!

2. Sketch her thigh ovals. Sketch lines and ovals for her legs. Draw two half circles with a line under each to form her shoes.

3. Draw lines for her hair and pony tail. Add eyebrows and a line for her nose and mouth. Outline her upper body and arms. Draw a circle for the volleyball, in front of her left arm. Outline her legs and shoes.

   Erase guide lines.

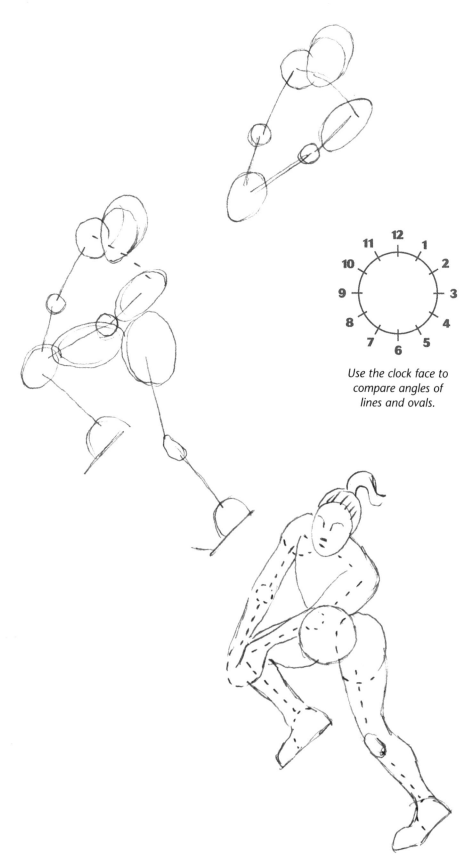

Use the clock face to compare angles of lines and ovals.

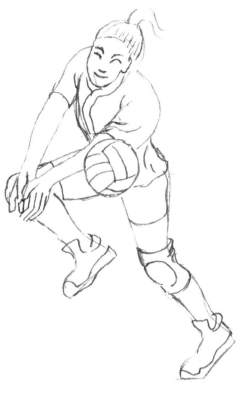

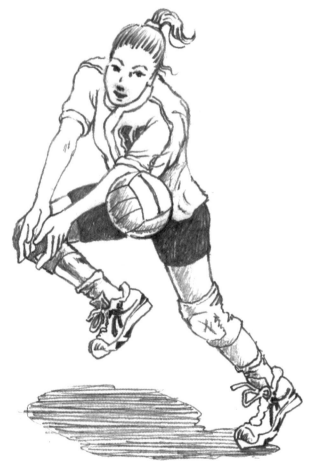

4. Add eyes, an ear, and extend her mouth line. Outline and detail her shirt and sleeves. Look at the design of the ball. Draw these lines.

Look closely at her hands. See how her fingers and thumb are lightly sketched tilted lines? Compare their tilt to the clock face. Draw these.

Add lines for her shorts and knee pad. Draw her shoes.

5. Now for the details to make this player more realistic. Draw more hair lines. Darken her facial features. Sharpen the outline on her jersey top. Add a numeral and piping. Shade her shorts. Sharpen the outline of her arms and hands, detailing her fingers.

Sharpen the outlines of her legs and shoes. Detail and shade her legs and knee pads. Design and detail her shoes. Don't forget the laces.

LOOK again! See any details, shading or shadows still missing? Add these now!

DRAWING TIP - When drawing hands, think of the fingers as angled lines. Duplicate the tilt of each finger and thumb with parallel lines, then add tips on the ends to enclose the fingers. Always use a well sharpened pencil for these fine details!

# Design a Hockey Mask

A combination of a catcher's mask and a knight's helmet, a goalie's mask looks like something out of the dark ages!

1. Sketch the tilted mask oval and guide lines dividing it into four sections.

2. Starting on the top left side, draw a "J" shaped line. Below the "J" line, draw a backward "L" shape with a cross line (on the center dividing line). From the bottom corner of the "L" shape, sketch a long curved line to the outer edge of the bottom right section. Draw three short curved lines, below this long line, to begin the base of the mask. Sketch the face opening in the lower right section. Carefully erase guide lines.

3. LOOK at the shapes in this drawing! Starting at the top left side, add a short curved line, above the "J" shape. Add the two shapes inside the "J" shape. Erase the original oval line below the "J" to shape the back of the mask. LOOK at the front of the mask. Add three straight lines above the face opening and a line down around the face shape. Add the additional shapes and lines you see on the base of the mask.

4. Add the curved lines that criss-cross the face section.

5. Look closely at the final drawing. It's a maze of lines and logo. Starting at the top, add details and a logo of your choice. (A dragon logo is always my choice!)

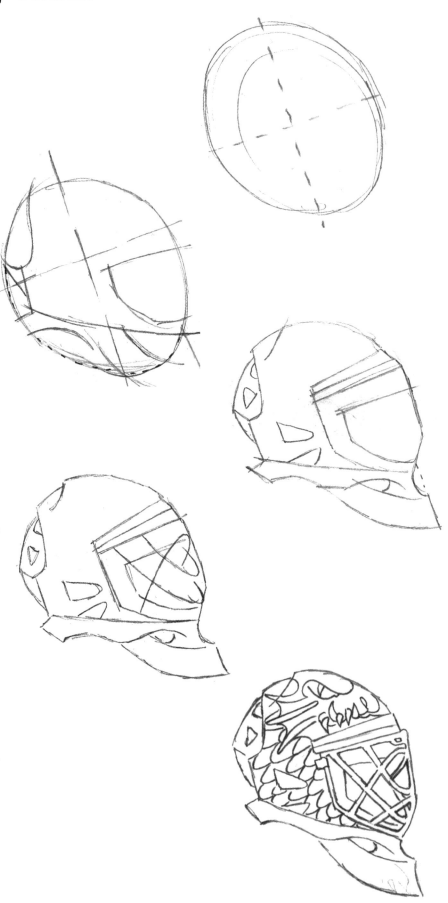

# OLYMPIC ATHLETES

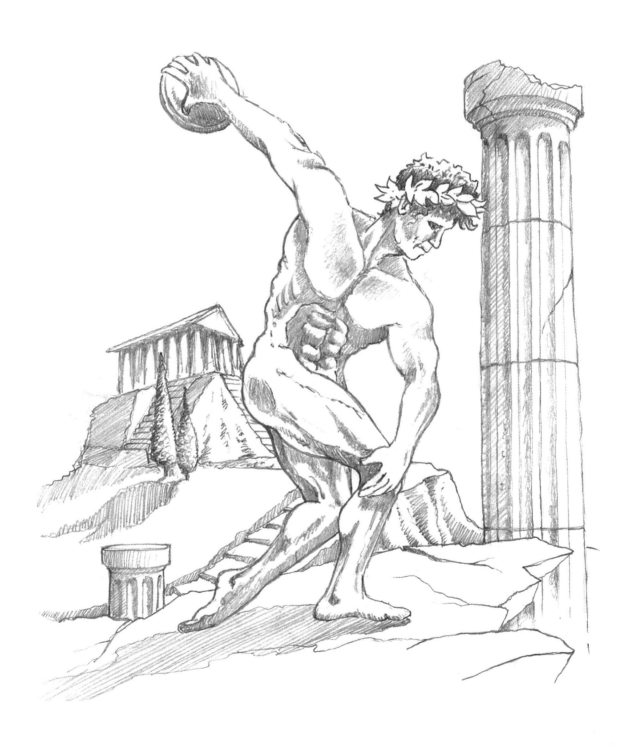

# The Discus Thrower

Nothing evokes the spirit of the original Olympic games like the image of the discus thrower with his finely tuned frame poised to launch his disc skyward!

1. LOOK carefully at the angles and shapes in the final drawing. Lightly sketch an oval for the head. Sketch a large oval for the upper body. Sketch a parallelogram (a plane figure with four sides, having the opposite sides parallel and equal) for his waist. Sketch a flat oval for his upper thigh.

2. Draw a line for the neck. Sketch two shoulder ovals. Sketch lines to form his pectoral (chest) muscles. Sketch a curved line to shape his mid section. Outline his waist and upper body. Sketch rods (lines) and joints (ovals) for his left arm and hand.

3. Sketch rods and joints for his outstretched discus arm. Sketch a large circle on the end for the discus. Draw a line across his head to begin the laurel wreath. Outline his free arm. Draw lines to form his stomach muscles. Sketch rods and joints to form his legs and feet.

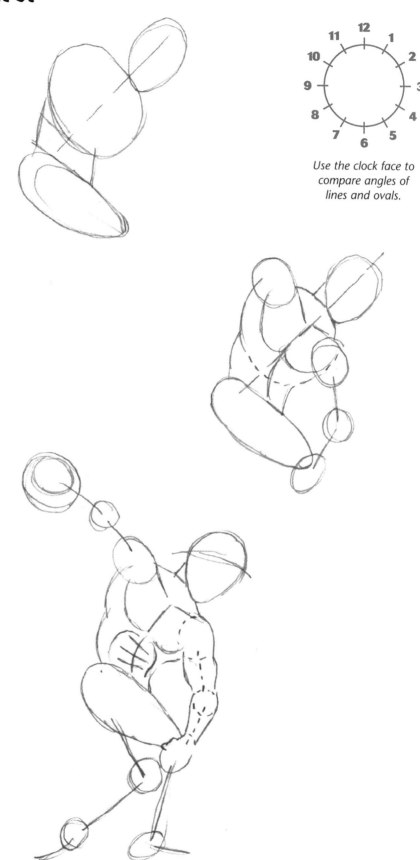

*Use the clock face to compare angles of lines and ovals.*

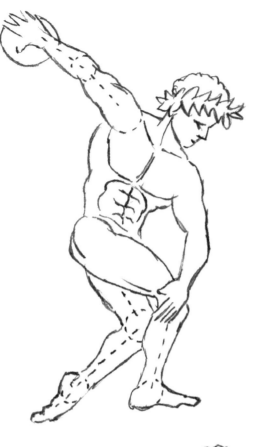

4. Add squiggly lines for the hair. Draw leaf shapes to form the wreath. Outline the face profile. Draw the eye and mouth.

   Outline the discus arm, hand and fingers. Sharpen the outline of the free arm. Draw the fingers and thumb. Outline the legs and feet.

   Erase guide lines.

5. Carefully observe the fine details in this finished drawing. See the muscles, the shading, the shadows on this figure?

   Starting at the top, add all details you see.

   A WINNER!

# The Split Leap

One look at the final drawing of this gymnast and you know she is clearly airborne, and clearly the most symmetrical sports figure in this book!

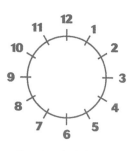

Use the clock face to compare angles of lines and ovals.

1. First sketch a center guide line to divide the mirrored forms on each side. Sketch an oval for the head. Sketch the upper body oval. Add a "U" shape to begin her collar. Sketch two ovals for shoulders.

2. Draw a line on each side to form her slim waist. Sketch a diamond shape for her pelvic area. Sketch two flat ovals to form her muscular thighs.

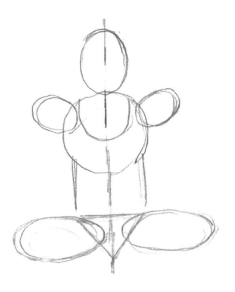

3. Draw her hair line. Add neck lines. Draw another U shape to complete the collar. Sketch rods (lines) and joints (ovals) for her outstretched arms. Sketch the triangular shaped hands. Sketch the block letters across her torso. Outline her upper body and waist.

Sketch the rods and joints to form her extended legs. Sketch her pointed feet.

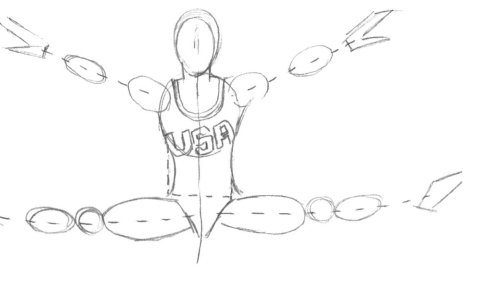

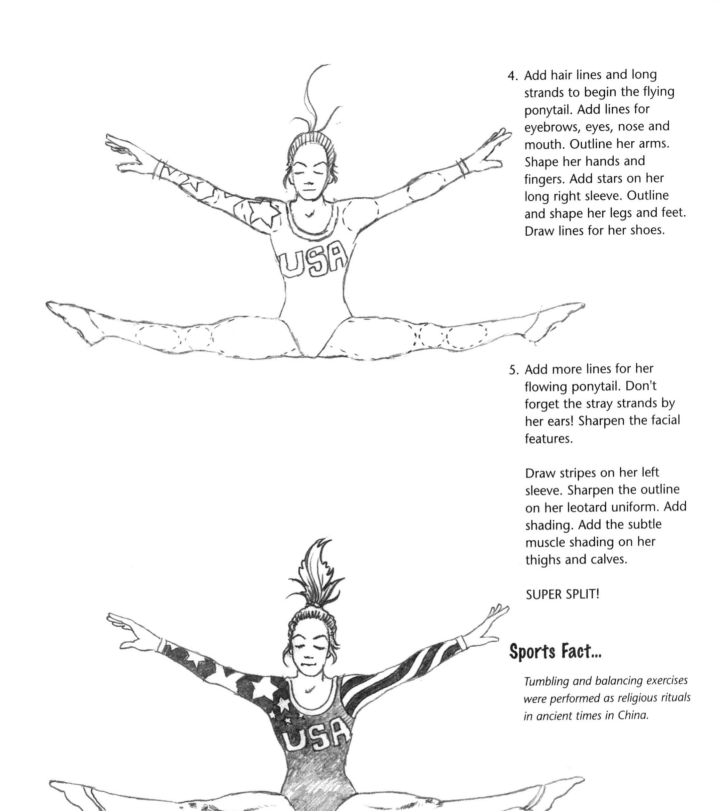

4. Add hair lines and long strands to begin the flying ponytail. Add lines for eyebrows, eyes, nose and mouth. Outline her arms. Shape her hands and fingers. Add stars on her long right sleeve. Outline and shape her legs and feet. Draw lines for her shoes.

5. Add more lines for her flowing ponytail. Don't forget the stray strands by her ears! Sharpen the facial features.

Draw stripes on her left sleeve. Sharpen the outline on her leotard uniform. Add shading. Add the subtle muscle shading on her thighs and calves.

SUPER SPLIT!

## Sports Fact...

*Tumbling and balancing exercises were performed as religious rituals in ancient times in China.*

## Sports Question...

*What culture coined the word gymnastics?*

# The Shot Put

The shot is made of heavy metal and it takes a heavy weight competitor to put the shot from the circle. Competitors use their body weight to aid in launching the shot.

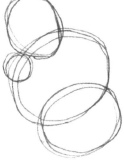

Use the clock face to compare angles of lines and ovals.

1. Sketch an oval for the head. Sketch an oval for the torso, and another for mid section. Sketch a circle for the round metal ball.

2. Draw three, short lines on his face to begin the nose and mouth. LOOK at the position of his arms. Sketch rods (lines) and joints (ovals) to form the arms.

   Sketch a triangle for his pelvis beneath his mid section. Sketch two long ovals to begin his powerful, thick upper legs. Sketch two light circles for his knees. Sketch rods and joints to form the lower legs and feet.

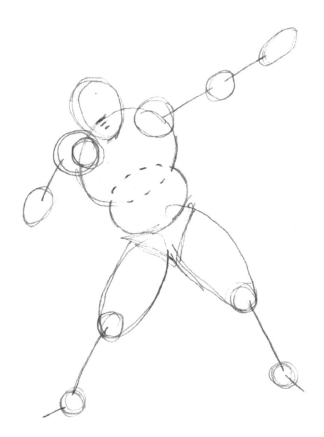

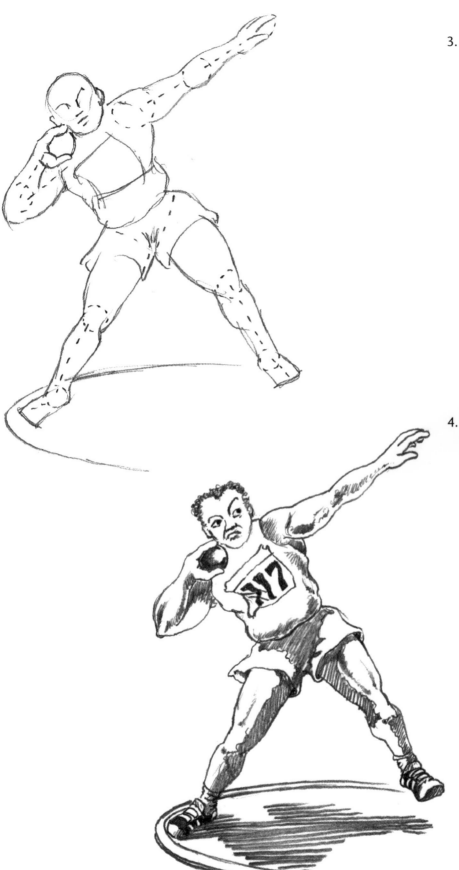

3. Sharpen the head outline. Add lines for the eyebrows, nose and mouth. Draw the small ears.

Outline and shape his arms and hands. Outline his upper body. Draw a rectangular shape on his chest.

Draw his shorts. Outline his legs and feet. Draw the curved line to begin the circle.

Erase guide lines. Clean up any smudges with your eraser.

4. LOOK at the final drawing. Starting at the top, carefully observe the light and dark contrast. See the white, black and gray in everything—the curly hair, two eyes aimed at a distant goal, the determined mouth and jaw, the white uniform with the black numeral, the dark shot put with white highlight, the muscular body and sweaty uniform.... See the cast shadow and the raised left leg?

Add the details and shading you see. Detail and shade until you can feel the explosive power being unleashed in this competitor.

# The Bodybuilder

Although not yet an Olympic event, body building is certainly a major sport in its own right. There is even a professional competition called the Mr. Olympia! Looking at a bodybuilder gives you a way to see individual muscles.

1. LOOK at the final drawing! See the shapes and body angles? Sketch an oval for the head. Sketch two short neck lines. Sketch a wide "Y" centered under the head oval. Sketch two overlapping circles on each side to begin his shoulders and biceps.

2. Sketch a long circular line, from the outside of one shoulder oval to the other, to form the upper body. Sketch the curved pectoral muscle lines. Sketch the midsection oval, overlapping the upper body oval. Sketch the waist lines. Sketch the triangular posing trunks.

3. Look at the thunder thighs (long, thick ovals) on this body builder! Sketch these. Sketch two smaller ovals for his calves. Sketch two long guide lines to determine the angle of his pose. Sketch a half circle for his left foot, and a half oval for his right foot.

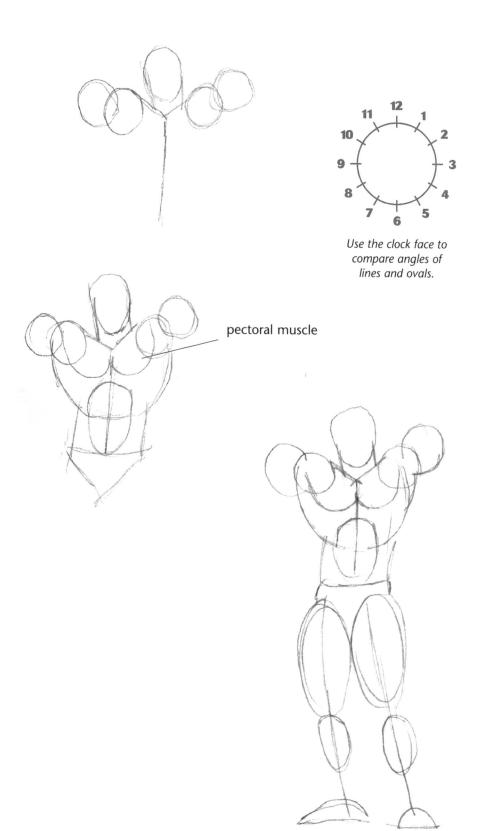

pectoral muscle

Use the clock face to compare angles of lines and ovals.

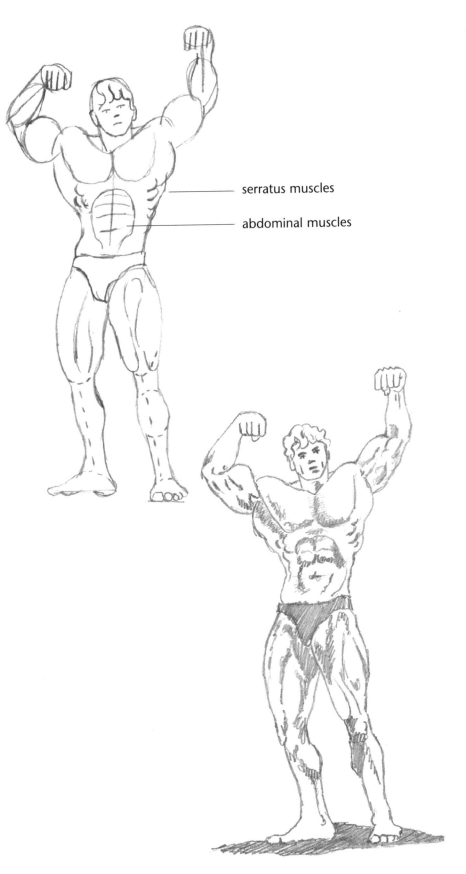

serratus muscles

abdominal muscles

4. Observe the angles of the powerful arms. Sketch ovals and lines to shape his arms and hands. Draw wavy hair lines. Add ears, eyes, nose and mouth lines.

   Draw the serratus muscles. Add cross lines in the mid section for the abdominal muscles.

   Outline, to connect and shape, his thighs, calves and feet. Draw long, curving muscle lines on his legs. Detail his feet with simple round toe shapes.

5. It's time to detail this power packed human! LOOK carefully at the contrast of light and dark. See the subtle shading?

   Starting at the top, add all details and shading you see.

## Sports Fact...

*Arnold Schwarzenegger (US) won 7 titles from 1970-1980 in the Mr. Olympia competition.*

## Sports Question...

*When was the first Ms. Olympia competition held?*

# Skeletal Muscles

LOOK! See the shapes!
Just as it is important to see how a complex skeleton can be drawn using simple rods and joints, it is equally important to know the musculature structure of the human body. Knowing how the major muscles are arranged will hep you draw any sports figure you chose.

A. Trapezius

B. Deltoid

C. Biceps branchii

D. Triceps branchii

E. Pectoralis major

F. Latissimus dorsi

G. Serratus anterior

H. Rectus abdominis

I. Quadriceps femoris

J. Sartorius

K. Gastrocnemius

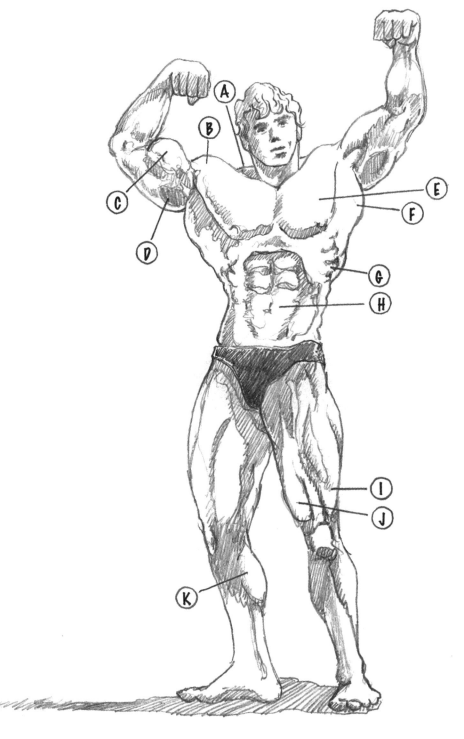

# INDIVIDUAL EFFORT

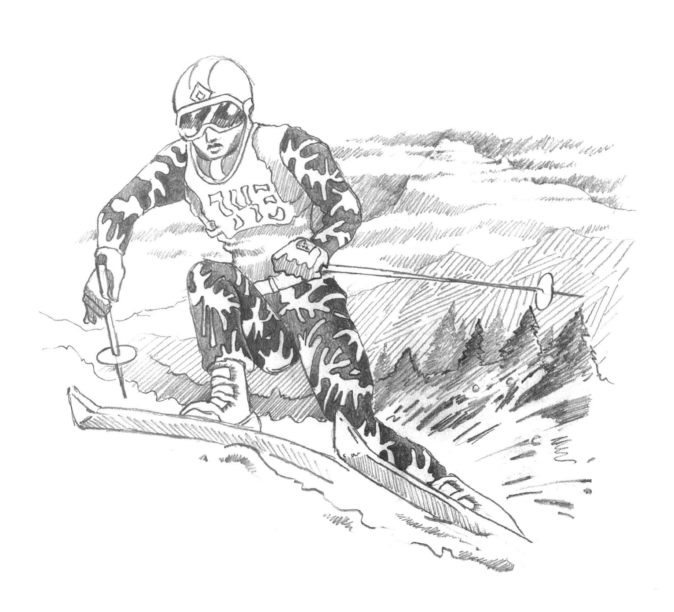

# Alpine Skiing

LOOK carefully at the final drawing. See the angle of this skier as she races her way down the slopes to the finish line. Compare the tilt of her head, shoulders, arms and hips to the clock face.

1. Sketch the cross guide lines you see. These will help you position the body parts at the correct angle.

   Sketch a tilted oval for her head. Sketch a larger titled oval, with a flattened top and a pointed bottom, for her upper body. Sketch an overlapping circle for her hips.

   Erase the guide lines.

2. Sketch two parallel lines across the head oval. Sketch rods (lines) and joints (ovals) to form the arms and hands. Outline the upper body.

   Sketch a circle for her right knee. Sketch a line for the lower right leg. Sketch a rectangle for her boot and a line to begin the right ski. Sketch a line and a circle to begin her left thigh and knee.

3. Look at the head. Add two lines to the top of the helmet. Reshape the bottom line for nose placement under the goggles. Draw a collar line beneath her chin. Outline and shape her arms and hands. Add the ski poles. Outline and shape the legs and boots. LOOK! Sketch the skis.

   Erase guide lines and any smudges.

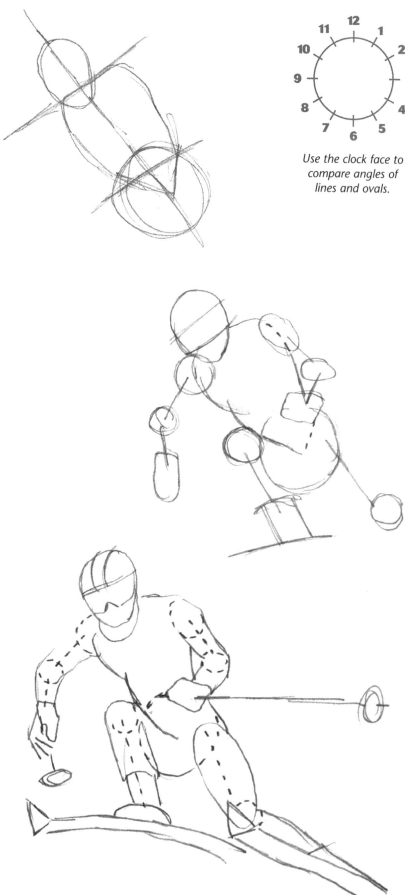

Use the clock face to compare angles of lines and ovals.

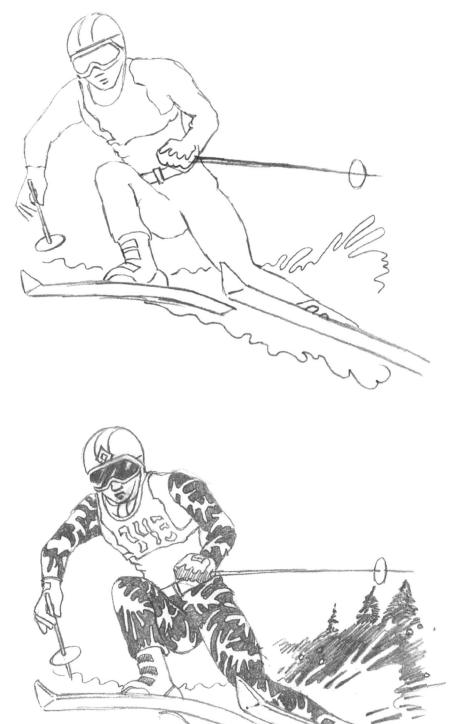

4. Starting at the top, outline and shape the goggles. Add nose and mouth lines. Sharpen ski suit lines. Draw squiggly vest lines. Add the belt lines. Draw lines to shape boots.

   Sharpen ski pole lines. Draw the boots. Sharpen the ski outlines. Add lines to suggest a spray of snow.

5. LOOK at the final drawing. See the difference when you add contrast with light and dark shading, and more details.

   Add details and shading. Sharpen outlines. Add a logo to her helmet. Design a wild ski suit. Make that powder spray as she makes her way down the slopes, across the finish line and into 1st place.

## Sports Fact...

*More than forty years ago skiers hit a top speed of just over 100 miles per hour.*

## Sports Question...

*In 1995 which U.S. skier set the world mark of 150.028 miles per hour?*

# Skater Dude - Hand Plant

This "Rad" skater dude makes many a difficult move, but the hand plant is by far the most radical.

1. LOOK at the amazing balancing position this skater is in. See how all the body parts stack one on top of the other along the vertical guide line! Lightly sketch the guide line to help you place each body part in the correct position.

   Sketch the knee circle. Sketch an overlapping oval for the thigh. Sketch another larger circle for the hips. Sketch the overlapping large body oval. Sketch an oval for the head.

2. Starting at the top, add the other knee circle. Sketch rods (lines) and joints (ovals) to form his calves and feet. Sketch rods and joints for his right arm. Lightly sketch the skateboard lines. Outline the thigh and hip area, to begin his baggy shorts. Outline the upper body and neck area to begin his shirt.

   Outline the helmet and strap. Draw his profile in detail (see insert). Lightly sketch goggles over his eyes.

   Now for that hand plant. Sketch a vertical line for his left arm. Sketch a horizontal line with a half dome shape on it to begin his planted hand. Halfway between the face and the hand, sketch a box shape for his elbow pad.

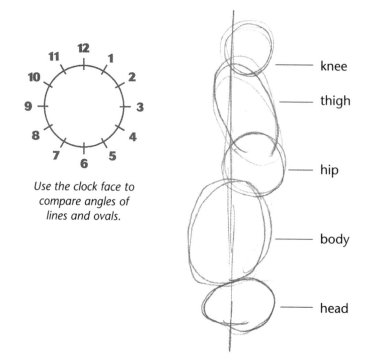

*Use the clock face to compare angles of lines and ovals.*

knee

thigh

hip

body

head

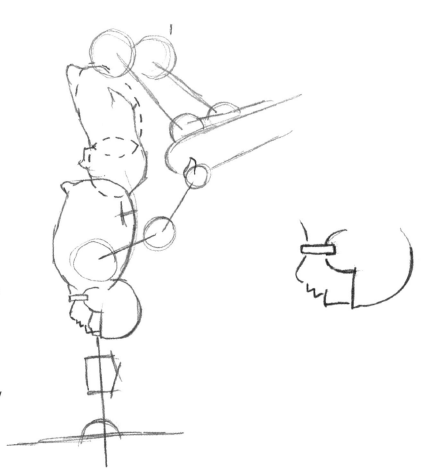

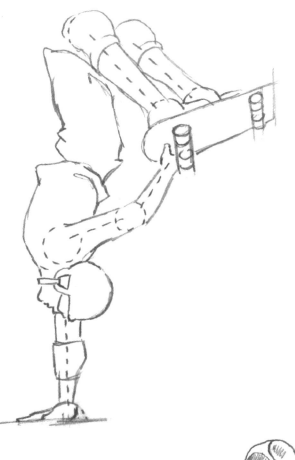

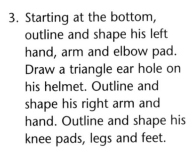

3. Starting at the bottom, outline and shape his left hand, arm and elbow pad. Draw a triangle ear hole on his helmet. Outline and shape his right arm and hand. Outline and shape his knee pads, legs and feet.

Sketch some simple wheels on his skate board, and add the front edge.

4. Now for the details and shading to make Rad a real skater dude.

Add vent holes to his helmet. Detail his elbow and knee pads. Rad needs a back pocket, some socks, shoes, wrinkles on his shirt and baggies....

Anything else missing?

Erase guide lines, and clean up smudges!

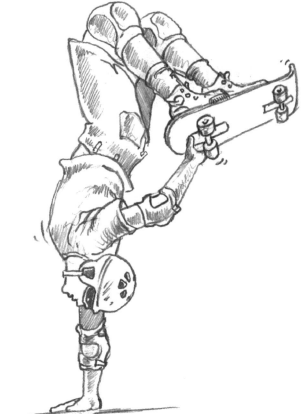

# Cliff Diver

The cliff divers of Acapulco have always intrigued me with their elegant dives and smooth landings.

1. LOOK at the final drawing. See the shapes! Compare the body angles with the clock face.

   Sketch the tilted shield shape. Sketch an oval for the head, and connect it to the head with two tilted parallel lines.

2. Sketch rods (lines) and joints (ovals) to form his broad shoulders and outstretched arms.

   Sketch a large circle for his hip.

   Sketch a light curved line, from the bottom of the head oval down the center of the upper body, to indicate the middle of his chest and abdomen.

   Notice the angle of his arched thighs. See how close together he holds his legs and feet. Sketch rods and joints to form the legs and feet.

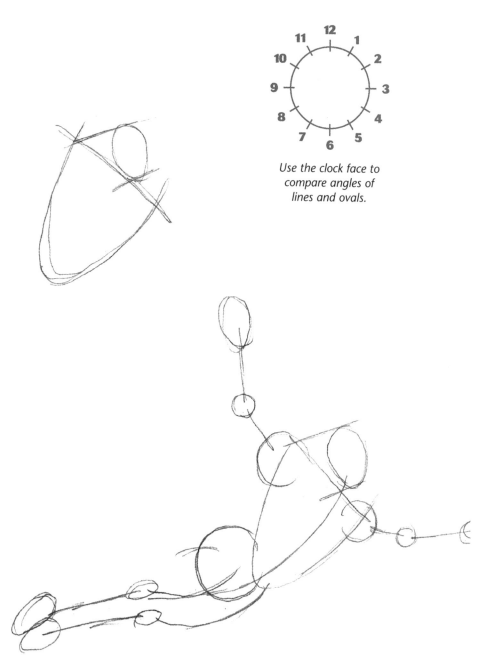

*Use the clock face to compare angles of lines and ovals.*

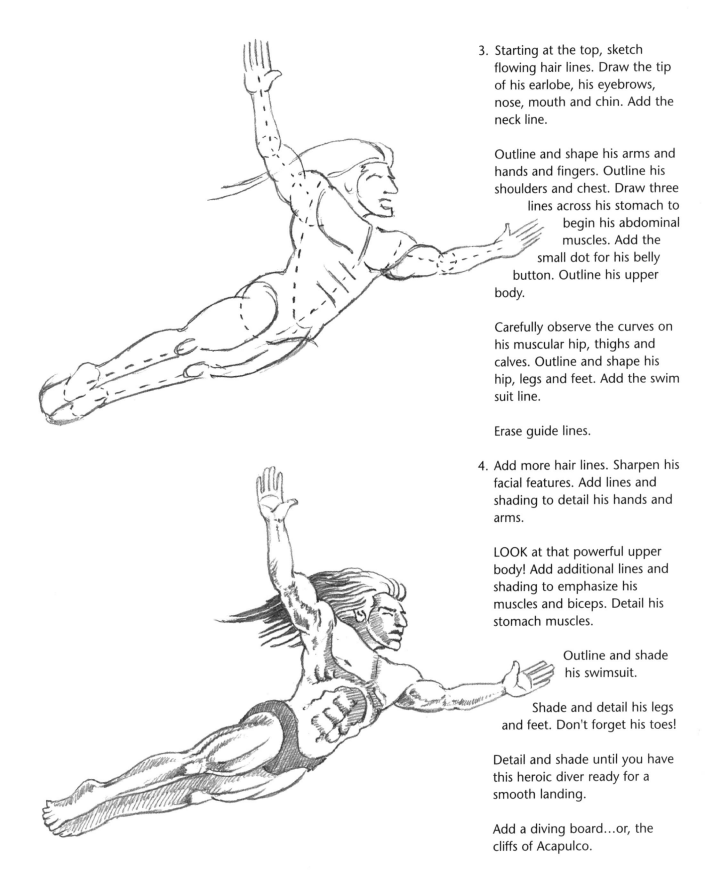

3. Starting at the top, sketch flowing hair lines. Draw the tip of his earlobe, his eyebrows, nose, mouth and chin. Add the neck line.

Outline and shape his arms and hands and fingers. Outline his shoulders and chest. Draw three lines across his stomach to begin his abdominal muscles. Add the small dot for his belly button. Outline his upper body.

Carefully observe the curves on his muscular hip, thighs and calves. Outline and shape his hip, legs and feet. Add the swim suit line.

Erase guide lines.

4. Add more hair lines. Sharpen his facial features. Add lines and shading to detail his hands and arms.

LOOK at that powerful upper body! Add additional lines and shading to emphasize his muscles and biceps. Detail his stomach muscles.

Outline and shade his swimsuit.

Shade and detail his legs and feet. Don't forget his toes!

Detail and shade until you have this heroic diver ready for a smooth landing.

Add a diving board...or, the cliffs of Acapulco.

**Draw SPORTS FIGURES** 57

# On Guard!

The modern sport of fencing was developed directly from the historical tradition of dueling with swords. This lunging fencer is a great challenge to draw, but no match for your flying pencil!

*Use the clock face to compare angles of lines and ovals.*

1. LOOK closely at the final drawing.

   Sketch two tilted ovals (one inside the other) for the fencing mask. Sketch a larger oval with a pointed bottom for the body. Add a line for the waist. Sketch the two shoulder ovals.

2. LOOK at the angles of the arms. Sketch rods (lines) and joints (ovals) to form the arms.

   LOOK at the position of the legs. Sketch two long ovals for the thighs. Sketch two circles for the knees. Sketch rods and joints for the calves and feet. Add a line to begin the right foot and two lines to form the left foot.

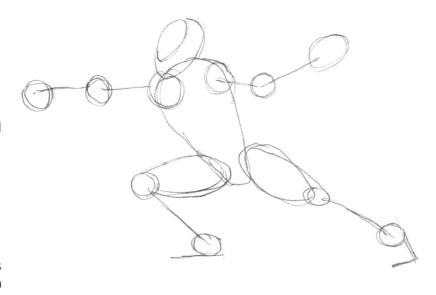

3. Outline and shape the arms. Add the rounded hand cup guard to the foil hand. Outline and shape the left hand and fingers.

   Outline and shape the legs and feet.

   Erase guide lines. Clean up smudges with your eraser.

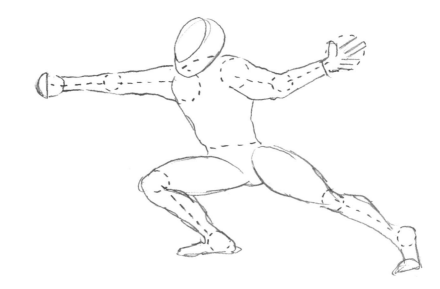

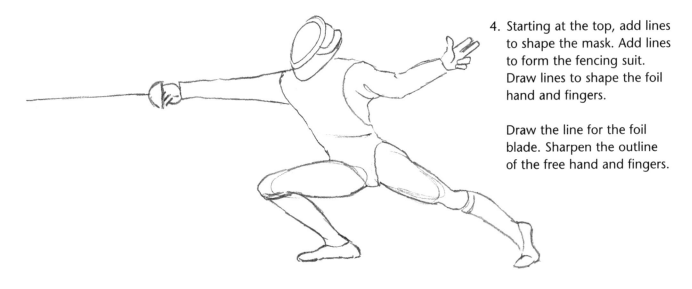

4. Starting at the top, add lines to shape the mask. Add lines to form the fencing suit. Draw lines to shape the foil hand and fingers.

Draw the line for the foil blade. Sharpen the outline of the free hand and fingers.

Draw stocking lines below the knees. Draw shoe lines.

5. LOOK at the contrast when you add more details and shading.

ON GUARD! Add the details and shading you see.

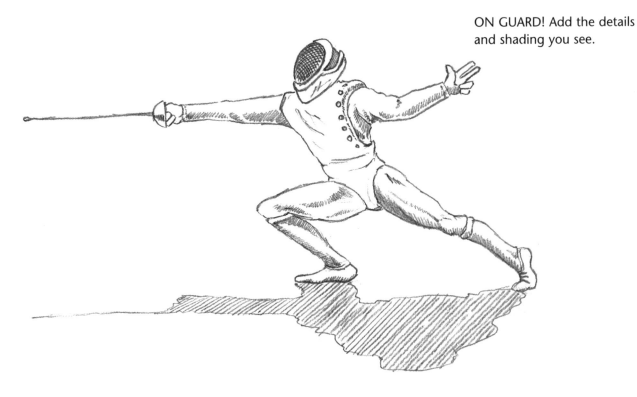

# Extreme! The Snowboarder

By now you are an expert at setting up figures in motion using basic shapes and angles. RIGHT? Of course!

1. Look at this snowboarder's extreme pose. See how the long vertical right guide line starts at the hand and runs straight down the arm, along the torso to the end of the snowboard. See the bean shaped body? See the angle of the arms and legs? See the gentle bend of the snowboard?

   Very lightly sketch the ovals, circles and lines to form the snowboarder's head, body, arms and legs. Sketch the curved lines to begin the snowboard.

2. Starting at the top, outline her raised left arm and sleeve. Add lines to begin her ponytail.

   Sketch lines to begin her goggles. Draw lines for her nose and mouth. Outline and shape her vest. Outline her right arm.

   Outline and shape her legs. Draw lines to form her boots with buckles.

   Outline and shape her snowboard.

   Erase guide lines.

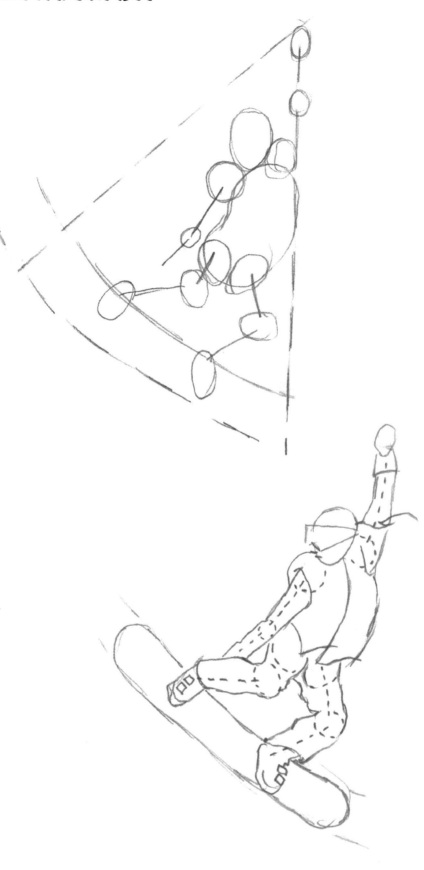

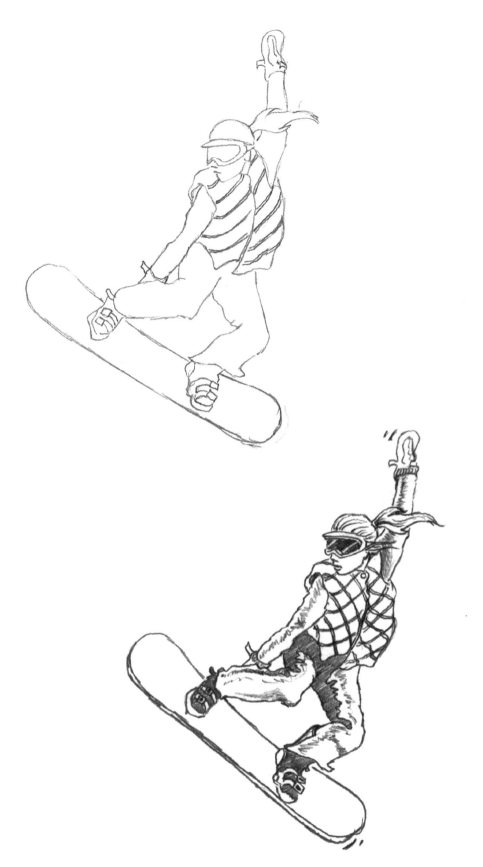

3. Outline and shape her left gloved hand with outstretched thumb.

   Add zigzag lines to form her ponytail. Add lines to shape the eye frames of her goggles. Outline and shape her jaw, face and earlobe.

   Add dark, accent lines to add bulk to her quilted vest. Add the glove strap on her right hand.

   Add boot lines for buckles and mount.

4. LOOK carefully at the final drawing. See the contrast of light and dark. What details have been added to create movement? What lines have been added for texture?

   Add details and shading. "Catch air!"

   Clean up with your eraser.

   Good Job! You have captured the balancing act of one extreme snowboarder.

# L'il Athlete

This young athlete is eager to be the best all-around player of the century. He carries his equipment to every sports event, just in case....

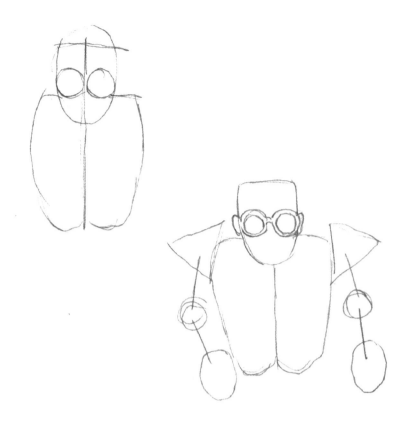

1. Sketch a flat topped oval for his head with a center guide line. Sketch two circles to begin goggles. Sketch two connected, body ovals with flattened tops to begin his chest protector.

2. Add his ears. Add circles and lines to shape his goggles. Erase guide line.

   Sketch triangles for his shoulders. Sketch rods (lines) and joints (ovals) to form his arms and hands.

3. Draw his hair line. Outline and shape his shoulders, sleeves and chest protector. Outline his left arm and hand. Outline his right arm and hand. Add finger lines. See what he's holding in his right hand?

   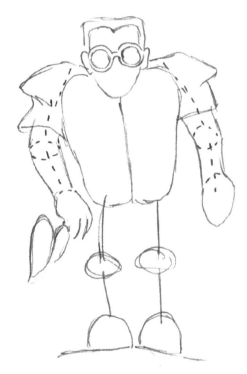

   Our Lil Athlete has a difficult time deciding which sport is his favorite. But, mention ROLLERBLADES and he's always equipped and ready to roll. So, draw the oval shapes (he's holding in his right hand) to begin the face guard section of his helmet.

   Sketch rods and joints for his legs and feet. Draw a line under each foot to show the position of his rollerblades.

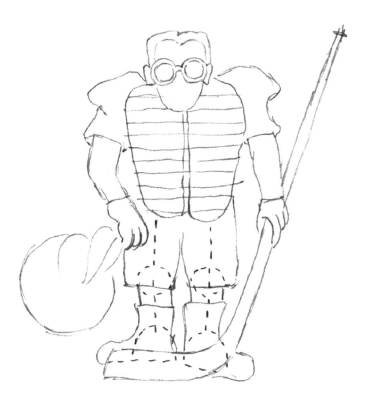

4. LOOK closely at the details added in this step. Add horizontal lines to detail his chest protector. Draw lines to shape his left hand. Add a sleeve line. Draw the hockey stick.

Outline his baggy shorts. Outline his legs and rollerblades. Draw his helmet.

Erase guide lines. Clean up any smudges with your eraser.

5. Check out the details added in this step. Add hair and facial features. Add a cup and more lines to shape his chest protector.

Draw lines to shape the face guard bars on his helmet. Add an ear hole. Design a logo for the side. Add lines and wheels to his rollerblade shoes.

6. Now, check out the great sports company L'il Athlete keeps on page 64. He's ready to play, and detailed to tackle any sport. Add details and shading you see. OH! Don't forget his wild, Hawaiian print baggy shorts! Surfs up!

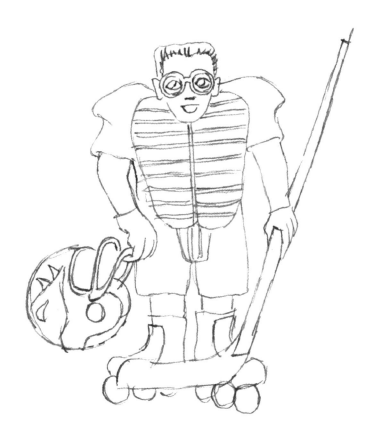

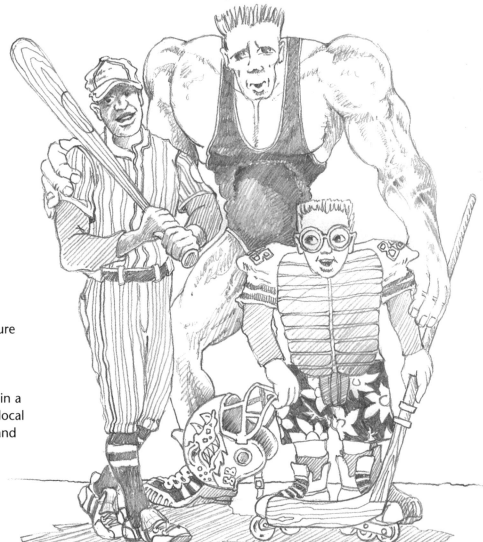

## Remember...

1. LOOK!
2. Sketch lightly!
3. Use your imagination!
4. Practice! Practice...
   ...and you're certain to
   score a Super Sports Figure
   every time!

P.S. Answers to the Sports
Questions can be found in a
variety of books in your local
library. Enjoy exploring and
drawing!